# Glyn Macey's
# WORLD OF ACRYLICS

# Dedication

For my beautiful wife and my
amazing children.

You are my world.

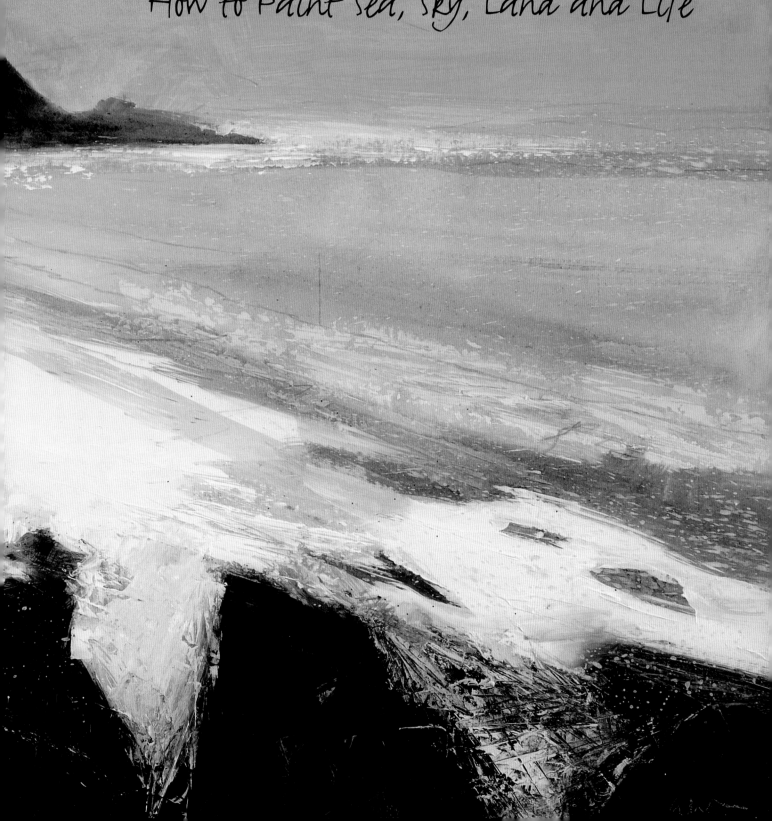

# Glyn Macey's
# WORLD OF ACRYLICS

## How to Paint Sea, Sky, Land and Life

First published in 2016

Search Press Limited
Wellwood, North Farm Road,
Tunbridge Wells, Kent TN2 3DR

ISBN: 978-1-78221-117-4

The Publishers and author can accept no responsibility
for any consequences arising from the information,
advice or instructions given in this publication.

Suppliers
If you have difficulty in obtaining any of the materials
and equipment mentioned in this book, then please
visit the Search Press website for details of suppliers:
www.searchpress.com

You are invited to visit the
author's website: www.glynmacey.com

Printed in China.

## ACKNOWLEDGEMENTS

A massive thanks to all of my friends at Search Press,
Winsor & Newton and Liquitex. You guys are all rock stars!

And to YOU, wherever you are in the big wide world, a
massive thank you for your interest and inspiration.

*Close your eyes and breathe deep!*

# Contents

# Introduction

*World of Acrylics.* Wow – that is a big claim, and when my editor proposed the title, I hesitated. Why 'world?' I pondered. Couldn't we call this book *How to Make Pictures With Paint and Stuff*, as that is essentially what I do? Thinking further on the title, I came to recognise the many links that I have with the word 'world'. I get to paint all over the world; I paint the world around me; and painting, in essence, is my world.

This book is about what goes on inside my head when I paint. We will certainly make pictures using 'paint and stuff' together, but this book is about more than that. It is about digging deep and delving down into your innate creative resources.

A quick word of warning before we start. I am not going to take your hand and lead you through a succession of baby steps to create pictures that look exactly like everybody else's work. This book isn't about spoon-feeding you. You don't need that. Instead, this book is about giving you ideas, inspiration and new ways of looking at your world – ideas that set you on your own path.

Yes, I will be beside you to make sure you do not get lost, and will help you over the hurdles that you will surely come across. But the path is yours: this book is first and foremost about your creative adventure. You will certainly find techniques and ideas here that ring true for you; ideas and processes that you can learn, adapt and call your own. When you find them, be sure to store them in that part of your brain that I like to call my 'bag of tricks'. You may also find ideas and techniques that don't appeal; you may even disagree with them: that's fine too. In fact, if you do find yourself disagreeing, that is better than fine as it shows that you are a 'thinking artist', and one with passion. Either way, be sure to drop me a line or show me your work at my website – I love a bit of banter!

Glyn Macey

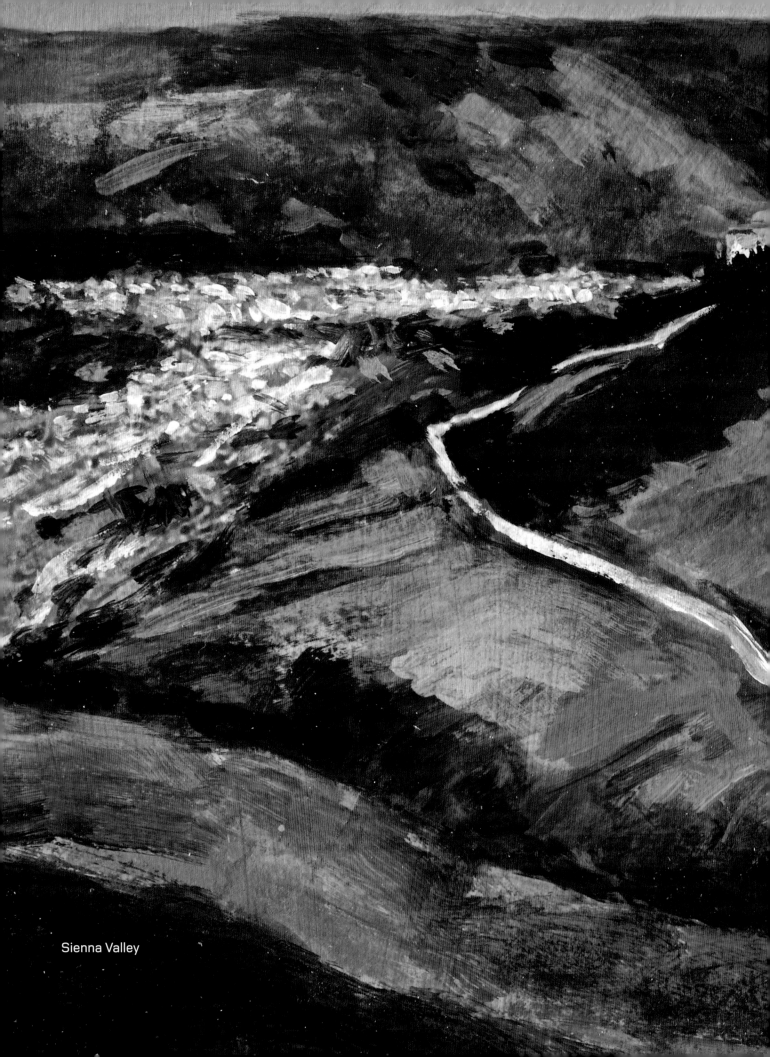

Sienna Valley

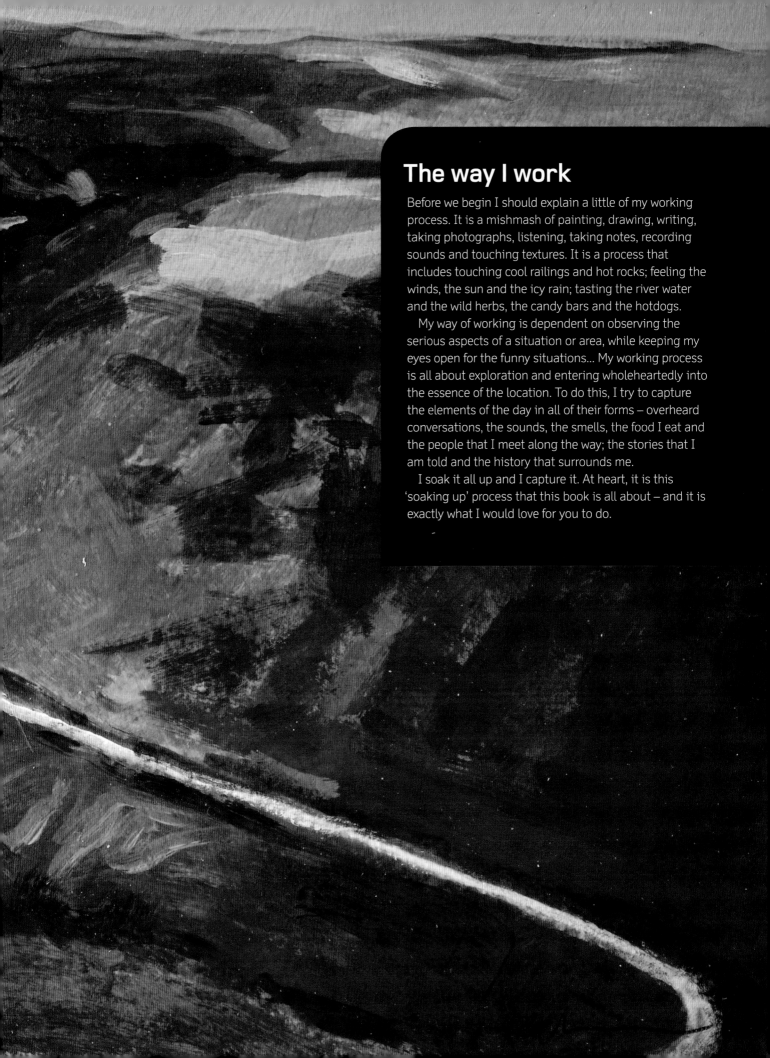

## The way I work

Before we begin I should explain a little of my working process. It is a mishmash of painting, drawing, writing, taking photographs, listening, taking notes, recording sounds and touching textures. It is a process that includes touching cool railings and hot rocks; feeling the winds, the sun and the icy rain; tasting the river water and the wild herbs, the candy bars and the hotdogs.

My way of working is dependent on observing the serious aspects of a situation or area, while keeping my eyes open for the funny situations... My working process is all about exploration and entering wholeheartedly into the essence of the location. To do this, I try to capture the elements of the day in all of their forms – overheard conversations, the sounds, the smells, the food I eat and the people that I meet along the way; the stories that I am told and the history that surrounds me.

I soak it all up and I capture it. At heart, it is this 'soaking up' process that this book is all about – and it is exactly what I would love for you to do.

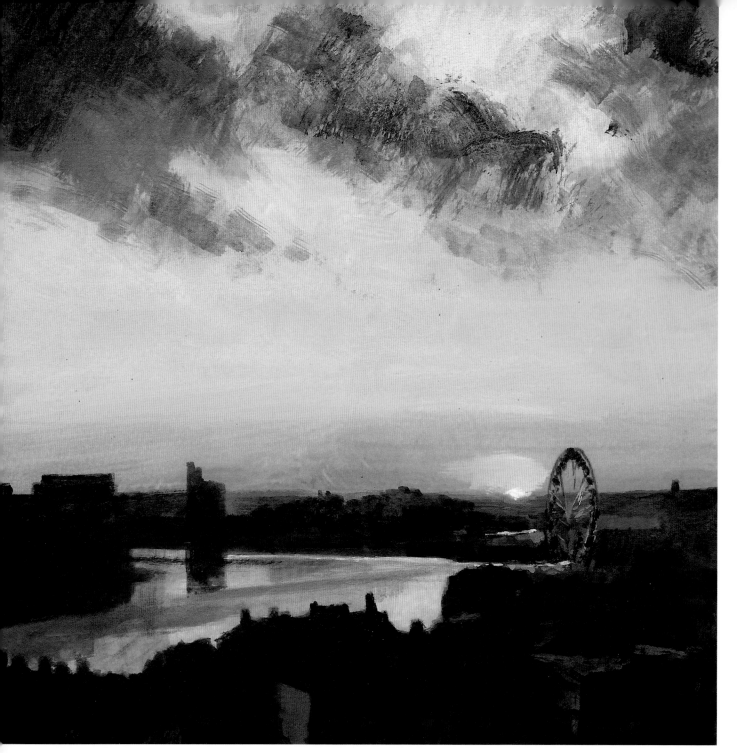

### Thames Sky

*'The river snakes onwards, geese fly over the city rooftops, sienna, scarlet, gold...'*

In this small study the silhouetted city skyline acts as a simple foil to the blazing sky.

*Opposite, top:*

### Venice

*Rich texture abounds in this most romantic of cities. Vivaldi in the air and seafood linguine for lunch – fantastic!*

*Opposite, bottom:*

### A Cornish Summer

*The fragrance of coconut sun lotion and sticky, melting ice cream. Tourists chattering over children's laughter... To create these impressions in paint, I used sharp-edged collage. Soft brushwork creates a neat foil against this.*

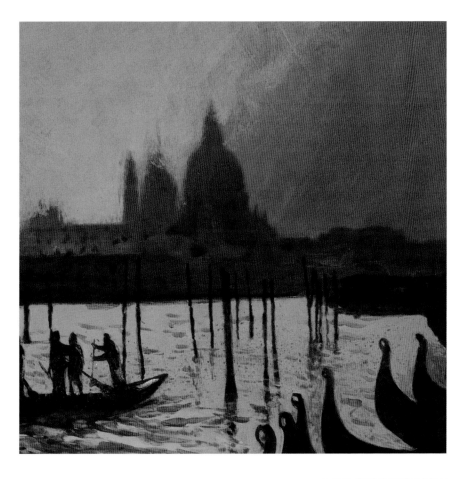

# Advice, not instructions

Ideas are exciting. I have my own favourite colours and textures and you will find your own too. That magpie process will help you discover and create your own style, instead of slavishly copying – yawn!

Throughout the book you will find suggestions of paints, brushes and other tools to use, and these are written to give you some guidelines if you need them. But to be honest, if I mention cobalt blue and you only have cerulean blue, that's great – use it instead and find out what happens. If I use beach sand and you live on a mountain, use the earth instead. What I am trying to say is that all colours, tools and approaches are equally valid.

If only this book had scratch 'n' sniff pages, you too could smell the hot desert fragrance of an Arizona night, fresh mackerel from the coasts of Cornwall, the sweat and steam of New York and the rich tobacco-scented coffee of Paris.

Similarly, if these pages could capture sound, you would hear the lapping of the Atlantic Ocean as it reaches the Bay of Biscay, or the gliding lap of a Venetian gondola.

If, by the end if this book, you are starting to experience and react to your surroundings in a slightly deeper, more creative way, I will sleep well. I hope that you too will capture a little of the excitement that I feel as I paint my way around this amazing planet.

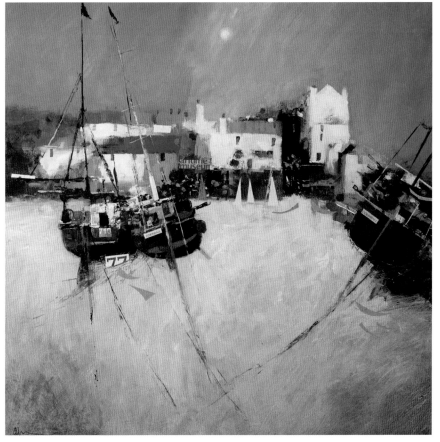

# Why acrylics?

Who would have thought that the relative newcomer on the art materials block would become the most versatile and widely used of all painting media? Fine artists of all descriptions, scene painters in the theatre, professional and amateur illustrators, and even graffiti and street artists all use (and abuse!) acrylics to their full potential. Why?

## Because acrylic paints are cool.

Perhaps that's a bit strong; but acrylics are certainly adaptable, interesting and exciting. Far more versatile than their lofty cousins oil and watercolour, acrylics hang out at all the best parties, making friends with all manner of equipment and found materials – from pencils to collage, pastels to inks – and hanging out with papers, boards and anything else that they can get to know.

Sometimes acrylic colour may play its music a little too loud, sometimes it may dress a little unconventionally, but it is always joyous and dances in the spirit of optimism.

At this stage I feel that I should tell you the history of acrylic paint; but to be frank that's largely irrelevant to my methods (not to mention a bit boring). Far better that I tell you an illustrative story that highlights why I have chosen acrylics as my medium of choice.

I attended a retrospective show of the work of a major artist who had been using acrylics since their development in the early 1960s. It was fantastic, but below the early paintings I saw hundreds of tiny flakes of paint falling gently like snow – all due to the original dodgy binders used with the pigments back in those days. It was for this reason that acrylics gained a dubious – and unfair – reputation. Fortunately, developments in the binders used mean that acrylic paint today now comes with great longevity. You can be safe in the knowledge that your paintings will outlast you, your children and theirs.

Acrylics are fast, versatile and striking – and those are three qualities that make them unbeatable for me.

# What do I need?

Looking around my studio, I can count at least seven different brush pots, each crammed full of brushes of all shapes and sizes. Bristly hoghair brushes, smooth sables and old household brushes for decorating all jostle for my attention. Where did they all come from? It is particularly mystifying when I realise that I rarely use more than two or three of them.

Before we begin, strip back your tools and equipment to the barest essentials: paints, a surface, and yourself. Look through your own painting box and ask yourself what is absolutely essential to your painting. That size 6 round sable brush is certainly nice to have, but you can produce work without it. So it's a 'no' – you do not need it. What about the painting knife? It's certainly fun to use, but so is a found piece of stone, or twig or – well, you get the picture.

The following pages look at what we end up with when we eliminate all unnecessary equipment and really pare down to the painting essentials. This process will set you up to make do with what you have and get you into the right mindset to experiment with your painting; to play around and learn to really enjoy the feeling of painting to please yourself.

# In the studio

## Acrylic paint

I use only a handful of colours – usually only four or five. The colours are chosen to suit the specific location, so my four chosen colours for painting in Cornwall, England will be different from those chosen for a painting done in the Arizona desert, for example. Because the location you choose to paint will be different from my examples, your colours will not be the same as the ones I used – this is why it is important to understand why you are painting as well as how to do it.

Experiment with colour. Look carefully around you to understand the tones and nuances of your surroundings and season, and pick paints that suit. The key is always the same – stick to a limited palette of just a small handful of colours. A blue, possibly a red, maybe a yellow, a white and your favourite earth colour. This small selection will allow you to mix every colour you need.

## Painting surface

For location work *en plein air* – that is, outside – I often carry a few small squares of mountboard with me on which to paint. This stiff cardboard is the same as that used in the framing process. It is an ideal surface for my way of working as it takes a wash well, is hard enough to take a scraping and a bashing from a painting knife, scalpel or piece of sharp stone, and finally (and crucially) this board is best friends with collage and takes all manner of found materials on board with ease.

However, as good as this board is, there is nothing better than finding a piece of material on which to create your masterpiece. For this reason you will often find me painting on driftwood, old signs, tin cans, discarded newspaper and pretty much anything else that I come across. Fortunately, acrylic paint is absolutely at home working in this way.

## Yourself

I know, I know, of course you must be there to do the painting! What I really mean is that you need to show up on a deeper level, with a really open mind. It is with this attitude that you will create your very best work.

What is a neat and fast way to open your mind? Try closing your eyes and breathing deeply a few times. The physiological reaction of deep breathing not only relaxes your body and mind but also opens your mind to suggestion. Think of it as meditation. What fragrances can you smell? The salty ocean? Decaying leaves in the forest? Petrol in the city? The local takeaway? Try to picture the colour that the aroma suggests. This may seem like an odd thing to do, but trust me, and trust your instincts.

Keeping your eyes closed, listen carefully. What can you hear? Birdsong? Conversation? Road traffic? The trickle of a stream? What colours do these sounds suggest to you? What shapes do these sounds and aromas convey? How would you draw the trickle of a stream? With one continuous line?

To answer those questions, read on.

# On the road

When I am travelling and working on the road, I like to travel light. With this in mind I pack a painting box with the real bare essentials. One large and one small brush, a palette knife, a small palette and a water pot. To this I add a few acrylic colours, and a small glue stick.

Just as important for me as the painting materials when I am travelling are my writing journal and mobile phone. Why the phone? For recording sounds: the incessant cab horns of New York, a diamondback snake rattle, conversation, wind, rain. The phone also allows me to take a playlist of music to immerse myself in... Gershwin, Lou Reed, Patty Griffin, The Beach Boys... whatever I please.

Finally, I bring along a 'tat' bag. I use a freezer bag to collect all manner of found ephemera: sand, shells, leaves and litter. These are all valid collage material, whether I end up using them on the spot or waiting until I'm home. All I need to do is open the bag and run the Arizona sand through my fingers. This combined with listening to my recorded 'found sounds' and I'm instantly there once again.

### Mid West

*This painting was made on location with the aim of capturing an approaching storm. Ominous rich dark clouds built overhead, dwarfing the mountains, and setting the ridge into sharp relief. I spread the paint around the foreground using my fingers to give instant texture and depth and saved smaller brush and palette knife strokes for the midground and distance.*

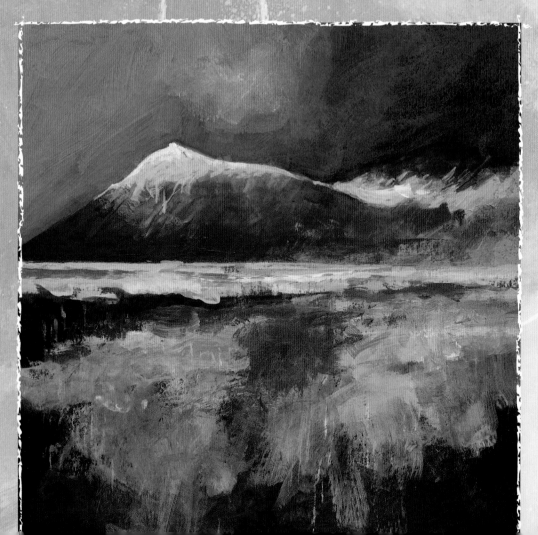

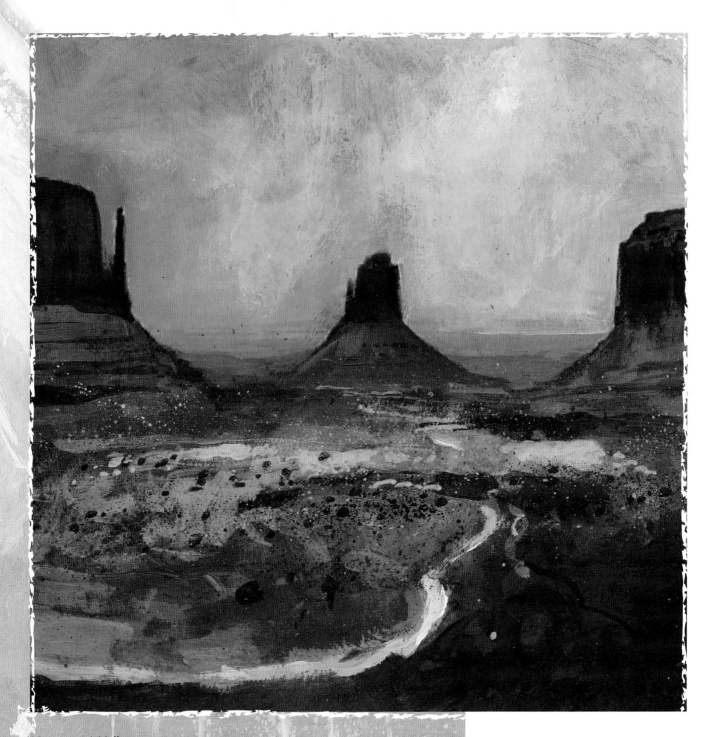

## Monument Valley

*Capturing the majesty of the sandstone buttes in Monument Valley in the USA can be tough. My solution was to dab and flick dark 'detail' into the valley floor to signify the scrub bush flora. Coupled with the suggestion of the track — a sinuous, snaking line, made with a found stick dipped in paint — these details help to give a sense of space and scale to the background.*

# What do I do?

So, how do you paint the trickle of a stream with one continuous movement? I must admit that it is pretty difficult to describe, and each artist's approach will be different. I like to close my eyes and let my hand hold the brush lightly, far down the handle. This imparts a certain loss of control when dancing the brush head gently across the painting surface, which results in fresh, natural strokes. Without wanting to sound too 'New Age', I imagine that I am the stream.

This approach holds true for any gesture or mark you make. Strong shapes need strong marks, while softer gestures will give more ethereal results. The examples on these pages should give you a head start on how to hold the brush, but have fun experimenting – there is no wrong way to paint.

### Control

*Holding the brush loosely nearer the bristles – as though it were a pen – gives you more control over the brushstrokes you make while still leaving you able to move it freely through using your wrist.*

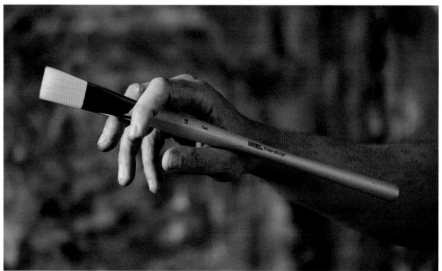

### Freedom

*The further back you hold your brush, the freer your brushstrokes will become. In exchange, you give up a little control; but this way of holding the brush gives big, expressive results.*

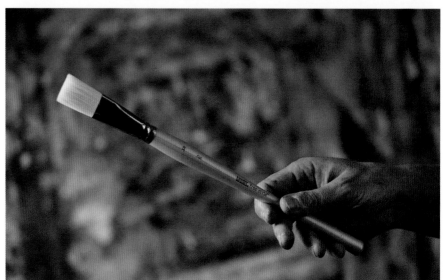

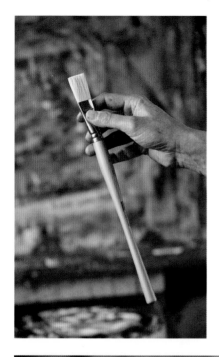
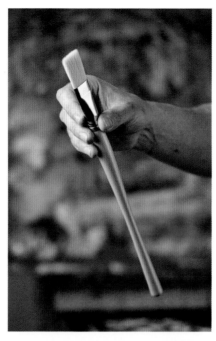

## Detail

*Experiment with holding a flat brush on the ferrule (the metal part that holds the bristles). This offsets the weight of the brush handle, and allows you to use the very corner of the brush to touch in fine points and details. The great advantage of this approach is that you do not need to swap to a small brush for detail, which means you do not need to break the flow of your work.*

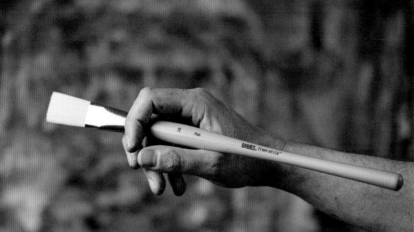

## Vigorous work

*Bracing the brush as shown lets you apply stronger strokes without the brush slipping out of your grasp. This is useful for applying thick horizontal strokes with the flat of your brush – perfect for quickly filling in large areas like sea, land or sky.*

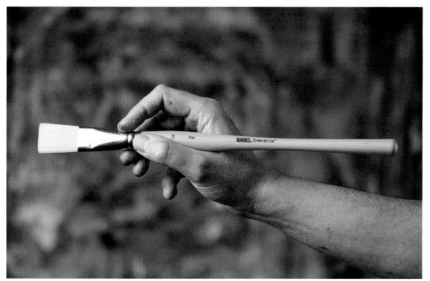

## Line work

*Fine lines are entirely possible even with a relatively large flat brush like this. Simply turn the flat of the brush to the correct angle, hold it steady and draw it lightly down the line you want to make. This is useful for rigging, manmade structures, the trunks of pine trees and other straight, fine lines.*

# WHAT COLOUR IS THE SEA?

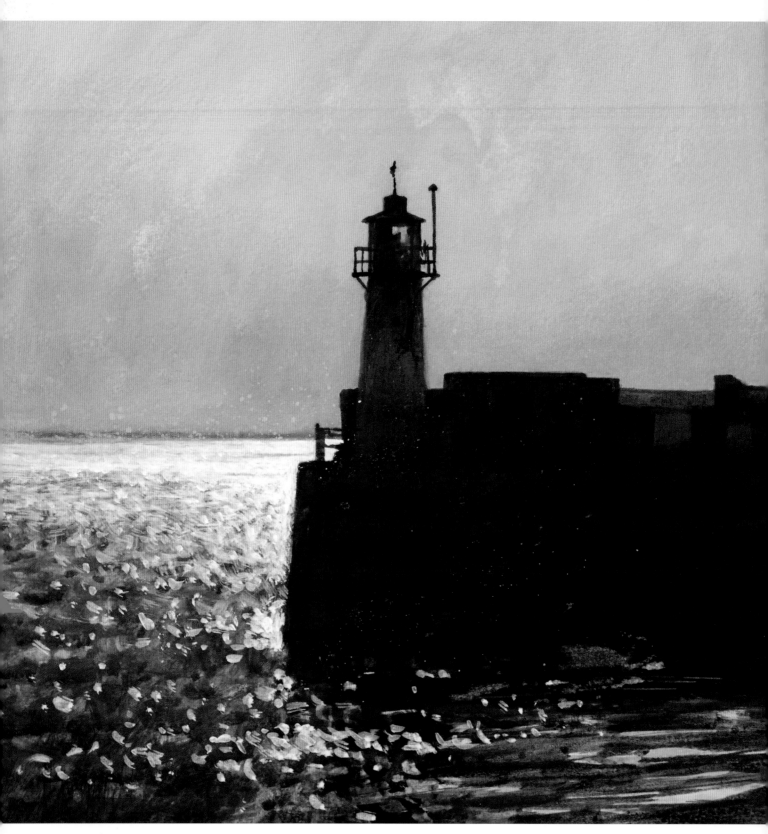

**A Newlyn Dawn**

*An exercise in using a very limited palette, to convey the calm stillness of an early morning.*

# The sea

When I was a child I met an elderly artist, sitting at the side of the harbour in my home town of Newlyn, Cornwall, working on a painting. I was fascinated, and stood watching the artist create the scene before him with deft brushstrokes of buttery oil paint. That smell of rich linseed oil as he scraped his brush and knife across the coarse canvas is unforgettable to me.

"That's brilliant!" I remember saying to the artist, transfixed by the painting.

"Thank you, young man," he replied, smiling. I became a little braver and asked,

"How do you become an artist?" Again, the artist smiled and paused briefly before asking me,

"Tell me young man, what colour is the sea?"

"Blue," I answered, without hesitation.

"Ah, yes, blue," he repeated. "And let me ask you, what colour is the sea?"

"It's blue," I repeated, starting to think that the old man was slightly crazy.

"Ah, yes. Blue, mmm," the artist pondered, then asked once more, "And may I ask, what colour is the sea?"

By now I thought that the old artist was completely crazy and I blurted out my answer: "It's blue! The sea is blue, and sometimes green, and there are dark grey waves and in the winter it looks black and when the sun is setting the sea is orange and yellow and pink!"

"Yes," said the artist, "the sea is all colours – and you, young man, are already an artist."

### The Mine under the Sea

*Another restricted palette was used for this* plein air *study. Cerulean and Prussian blue were used along with copious amounts of titanium white, all applied with staccato, choppy strokes to mimic the wave action.*

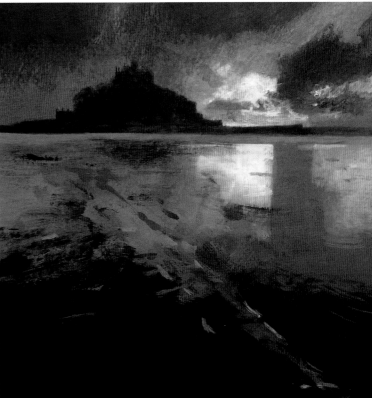

### Mount Sunset

*In comparison with the other examples on these pages, this painting uses a wider range of colours and calmer, more controlled brushwork to convey a gentle sea during a warm summer evening.*

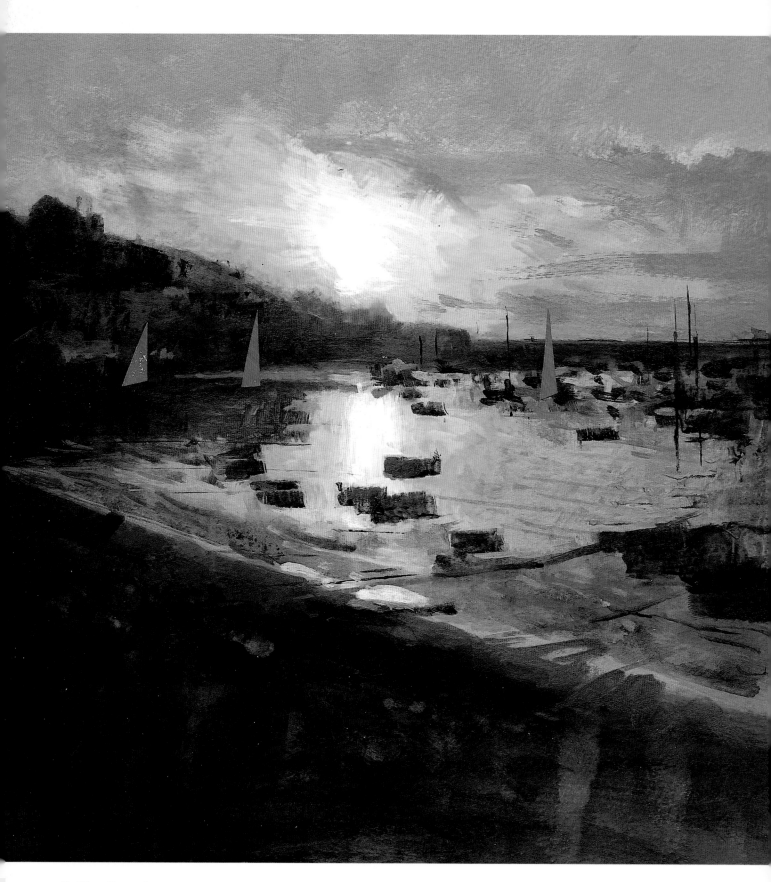

**Scillies Sunset**

*The sea always reflects the surrounding colours, so when painting a vibrant sunset, it makes sense to use the same colours, mixes and tones in the water.*

26 The sea

# Opportunities and challenges

The sea is all colours, and the sea is no colour. The sea reflects all that surrounds it, and it is this aspect that we are looking at in this part of the book. Whether a raging Pacific storm or a calm Mediterranean inlet, the sea resonates with energy. But how to capture that energy, that life, that movement? My personal response to capturing energy is to use corresponding mark-making techniques. By that I mean that I aim to mimic the action of the sea.

For example, when painting a stormy sea with large waves, I will use large, sweeping strokes with a large brush, a rag, a sponge or simply my hand loaded with paint. I will stand to make the marks and use exaggerated sweeping gestures. I imagine following the sweep of the wave with my arm. A choppy sea requires choppy strokes – push and pull in excited staccato. Stabbing strokes also work; fast, sharp; imagine you are fencing. Try using the acrylic paint watered down to the consistency of milk, and let the paint flick and drip. This alone creates energy, and a life of its own. Flat calm seas require fluid, long, languorous lines of wet, dripping acrylic paint. The kind of sleepy lines that you might make when drowsing. Lines that lull you to a meditative state. We can chat more about the specifics of these mark-making techniques as we explore this part of the book.

Light and colour go hand in hand through the painting process and never more so than when painting the sea in all of her moods. Let's explore a few of the many ways to portray the sea.

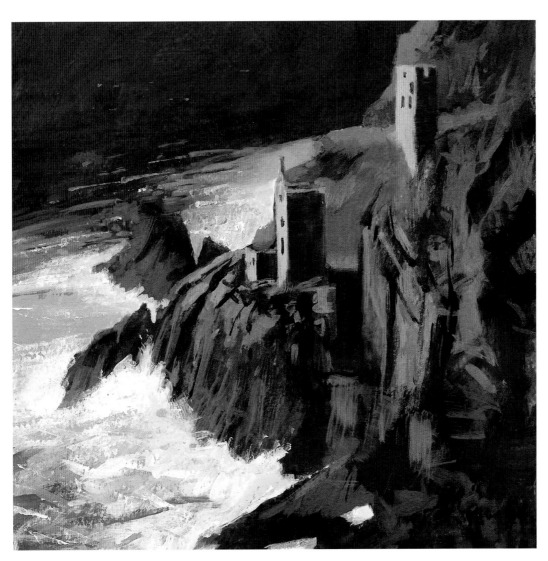

### Crowns Mine

*Sometimes, as here, the sea acts in a supporting role – it is part of the painting but is not the star of the show. In these circumstances I often paint the sea as simply as possible.*

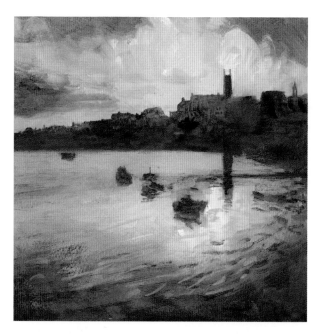

### Sienna Harbour

*To convey the warmth of the evening in this painting, I used ochres and sienna colours, together with subtle brushwork to describe the movement in the water. These brushstrokes help to move the viewer's eye into the painting and to create an all-important sense of space, which in turn gives scale to the town skyline.*

### Scillonian Blue

*As with Sienna Harbour above, this picture was painted with a very limited palette, but for a different reason. Here I used the sea area as a simple base for the main subject of the ferry. The ferry holds the work and detail, so too much work in the water would complicate the overall image and confuse the eye. Just a little collage in the deep blue water is enough to give interest.*

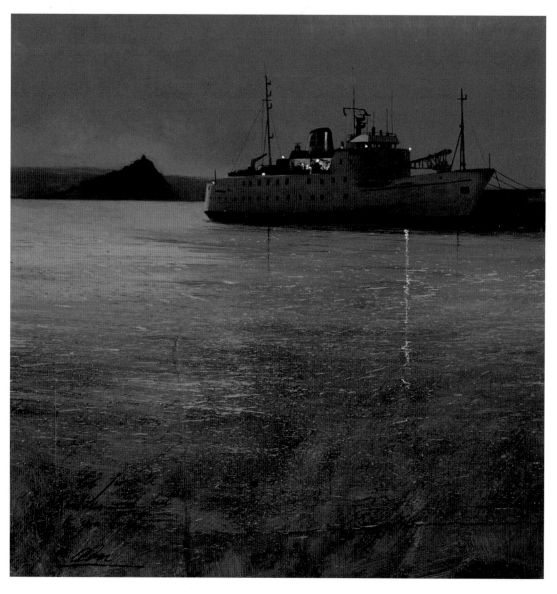

# Useful equipment

As I mentioned earlier, I like to travel light, so I take the bare minimum and use creativity to fill any gaps. The list below is a suggestion for what I might use to paint the sea, but I do encourage you to try different approaches.

### Mountboard
This is the board used in the framing process. It's pretty tough and inexpensive. The real beauty of mountboard is that it can take a wash of watered-down colour really well, while being strong enough to support found material collage, such as sand and shells.

### Brushes
When I'm painting the sea, often the only brush I use will be an old household decorating brush. You know the kind, the brushes with wayward bristles. It is precisely this wayward brush approach that works so well for capturing movement in the sea.

### Painting knife
These are wonderful for adding sharp 'wave' lines, flicked sparkle and for spreading on impasto foreshores.

### Acrylic paints
Acrylics are perfect for painting the sea, whether glazing wave shadows or adding staccato impasto highlights. As you will have seen in the sea painting examples, colour choice is down to you!

### Other materials
An old toothbrush can be really beneficial for a touch of 'flickety-flick' and when I'm working on large areas, a radiator roller really pays its way for covering large areas quickly and creating texture. Try mark-making using seaweed, old rope, driftwood and shells – and how about using these same elements as collage materials?

# The moods of the sea

As I write this chapter, sitting in my studio in West Cornwall in the UK, I am looking out of my window at a huge sou'westerly gale blowing in from the wild Atlantic Ocean. Huge waves crash on the shore below and salt spray is hitting the windows. The light, the atmosphere, the colour and the texture of the day is set by the sea. The sea dominates. But how can we capture these elemental forces? This is the focus for this chapter: how to capture the often wild, sometimes tame and always fleeting nature of water.

Over the next pages I will illustrate some of the ways that I paint the sea, rivers and lakes, and explain how I used them to paint both the pictures shown here and some contrasting examples to show different ways of using the same techniques. All these practical techniques are used for a reason and with a specific outcome in mind – from gestural mark-making with impasto colour to gentle sponge work.

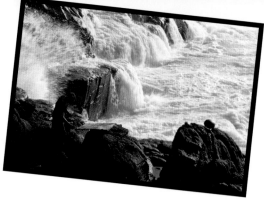

### Pedn Vounder, Cornwall

*My focus in this sea painting was to capture the long, deep drawl of a heavy swell. These waves are large and slow, so there is no need for frenzied brushwork. Languid, fluid marks work better to follow the purposeful action of the Atlantic swell. Deep blues and greens tone up beautifully with added white for sea foam, both sunlit and in shadow.*

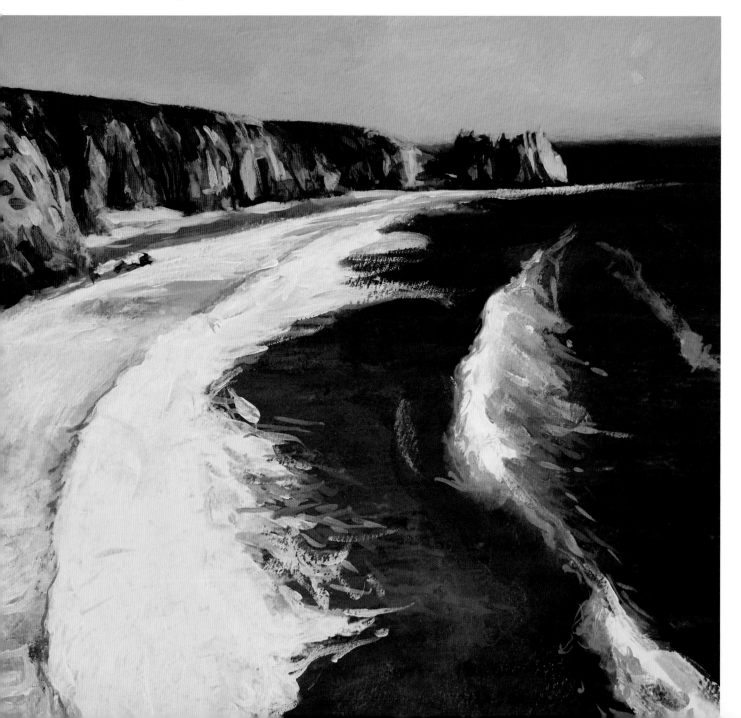

## Atlantic Swell

*I remember a real chill in the air while painting this study, and a strong gusty wind, which helped by blowing paint around the board surface. Always be ready to accept Mother Nature's helping hand!*

## Ullswater

*Large lakes like Ullswater in the Lake District, UK, share many characteristics with the sea, and you can use many of the same approaches you use for the sea for other large bodies of water.*

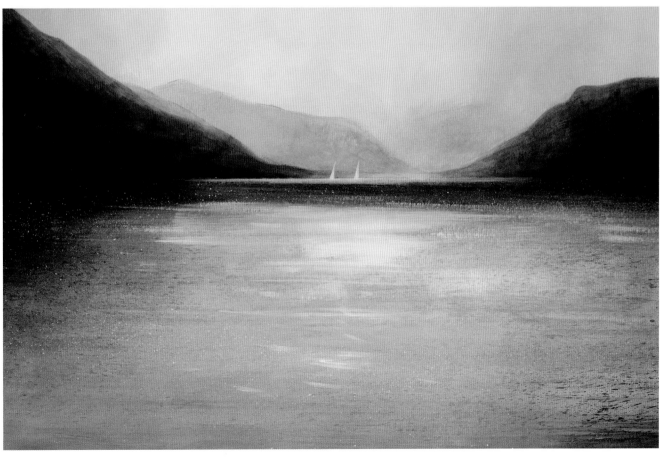

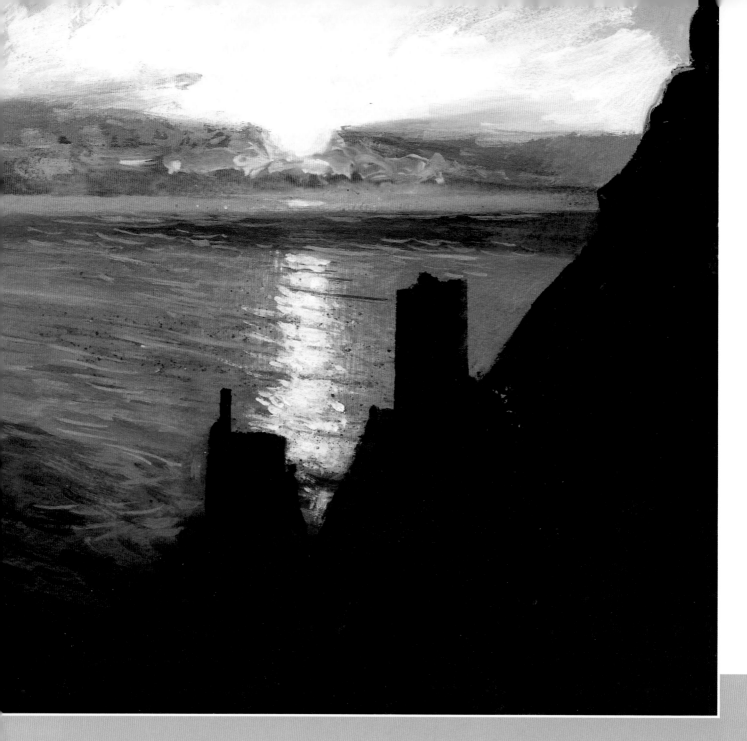

## Mark-making

Impasto techniques can be used really successfully when painting the sea. The nature of impasto creates highs and lows on the painting surface, and these abilities can really work in our favour, creating wavelike actions perfect for capturing, well, waves! A note to remember when using impasto mark-making is to reserve your largest impasto marks for the foreground, and in turn, small impasto marks for more distant elements in your painting. Using this contrast in size of strokes will really help to give your painting depth and space.

### Crowns Sunset

*For this sunset sea, I have chosen to use brush work with a wetter paint. Using wetter paint means that I lose the vigorous impasto peaks and troughs, but gain a more fluid control, perfect for a calmer sea. As discussed previously, a calmer sea needs calmer mark-making. The emphasis in this painting is the shaft of reflected sun on the otherwise dark sea. This sparkling light helps to throw the mine buildings into deep silhouette, creating shapes that are recognisable yet mysterious. The pale lemon yellows used in the sea are also used in the sky, giving unity while drawing the viewer's eye from sky down through the sea to the mines.*

# Impasto

The essence of the impasto technique is simply applying a thick layer of paint to the surface. This creates texture. However, the way you move the brush will affect how it deposits the paint, so experiment with how you apply the colour. Beyond those simple principles, the sky – or the sea – is the limit!

While technically possible with oils, the impasto technique works especially well with the heavy body and relatively quick-drying time of acrylic paint. You can blend wet colours smoothly or roughly, overpaint the result when dry, and generally have fun with this most iconic of acrylic painting techniques.

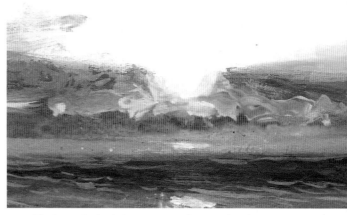

*The impasto technique was used in the sky of Crowns, most notably in the area around the sun.*

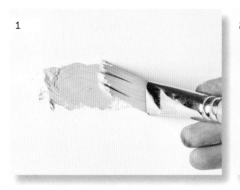
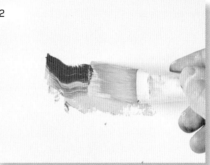
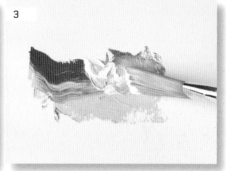

**1** Load your brush with plenty of undiluted paint, and simply apply it to the surface to deposit the thick paint. Twist the brush to apply the paint roughly or draw it smoothly for a flatter result with larger build-ups on the edges of the brush stroke.

**2** Without washing your brush, pick up some more thick paint of a different colour and apply it in the same way. As you draw the stroke, the colours will mix naturally without creating a smooth blend – this is a great way to create visual interest.

**3** Once dry, you can use acrylics to paint over the top of impasto work, allowing you to work in finer detail and refine the details should you so wish.

## Pedn Vounder, Cornwall

*A calm sea needs calmer mark-making – but for a sea like this, with great rolling breakers coming in, you can create vigorous impasto peaks with heavy paint marks, and use a more fluid control for the calmer bottle-green troughs. The emphasis in this painting is without doubt the sea, with those massive breakers in the heavy Atlantic swell. The vertical brush work in the cliffs brings further attention to the water by creating a counterpoint to the horizontal marks made in the waves and sea.*

*To add a certain wintery chill to this New Year's Day painting, made en plein air, I used a selection of very warm yellows, oranges and golds in the cliffs, safe in the knowledge that these very warm colours make the cool sea colours even more deep, cold and dramatic.*

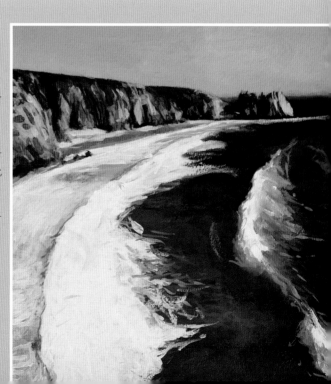

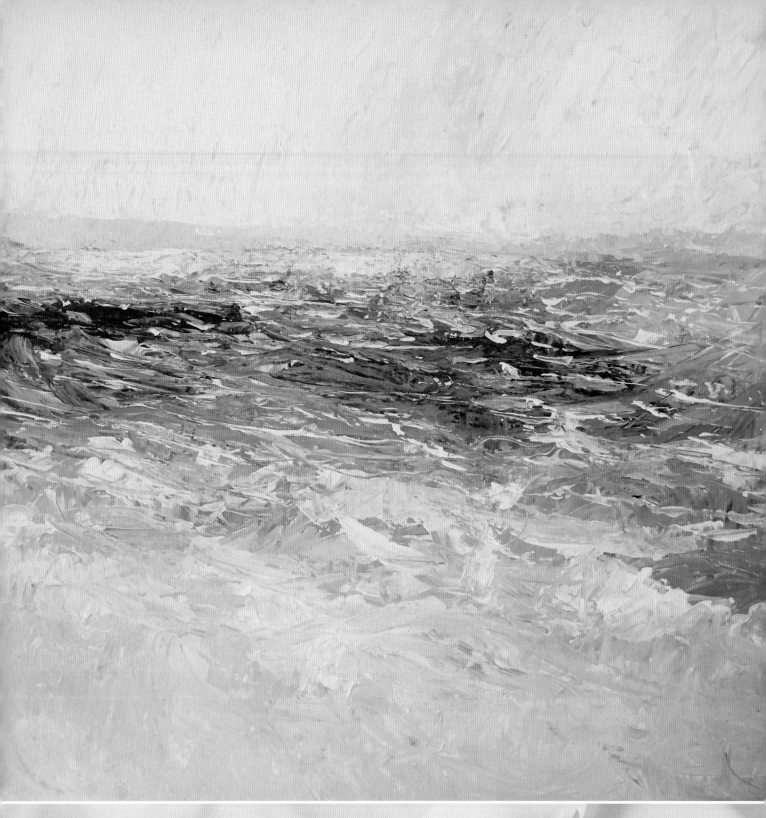

## Heavy texture

Impasto really comes into its own when using a heavy-bodied acrylic medium with abandon. By abandon I mean using vigorous mark-making strokes, trying to capture the energy and movement of the moment. When these energetic painting sessions go well, we should feel a little exhausted afterwards. Now is definitely not the time to hold back. Instead, attack the painting surface; spread, flick and mould it. Carve out the shapes, literally as well as metaphorically.

### A Big Sou'westerly

This was painted en plein air, *sitting on the rocks above the breaking waves and glowing foam. Sea spray rained down, salt filled the air. The waves crashed, moaned and sang a mournful song. Repetitive, thunderous sounds; deep, deep blues, greens, aquas, turquoise, petrol greys. Foam so white as to be near impossibly bright. How to capture the elements in their full force?*

# Using texture gel

Acrylic mediums are all basically acrylic paint without any colour added. They are used to alter the qualities of the paint – by slowing the drying time, for example. Texture gels (also called texture pastes or texture mediums), are a type of acrylic medium that can be used to add or alter the texture of the paint. They are available in various densities, from relatively liquid to heavy and thick. Thicker texture gels can be applied straight from the pot and painted over when dry or, alternatively, they can be mixed with acrylic colour before being applied to the surface – this is my preferred approach.

Texture gels really come into their own when painting rough seas. All of those random peaks and troughs, the swirls and breaks, can easily be translated with a scoop of texture gel and a painting knife. Try to 'feel' those sea shapes as you apply the texture paste. Think through how the movement is made before painting with confident strokes.

**1** Dip the painting knife into the texture gel to pick up a fair amount.

**2** Use the knife to apply the gel to the surface, smearing it about with the flat and blade of the brush to create the texture you want. Allow it to dry thoroughly, and then you can paint over it.

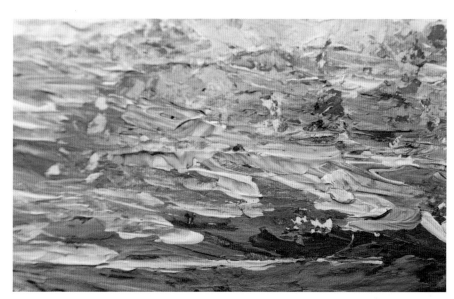

### Atlantic Swell

*Incorporating part of the shoreline into this painting allowed me to introduce striking textural contrasts to the rough, dominant sea. The shoreline is painted with smoother, straighter strokes and dryer paint, while the sea was treated in much the same way as in A Big Sou'Westerly. A palette knife was used to convey the choppy, staccato movement of the sea breaking over rocks in this painting.*

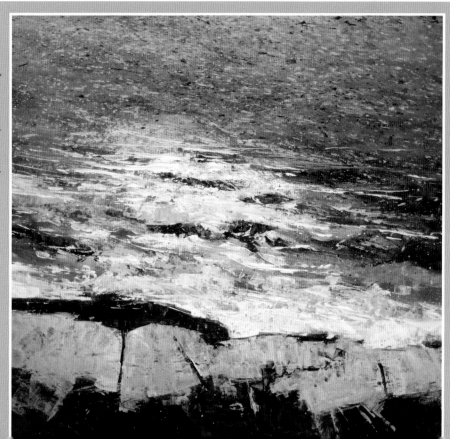

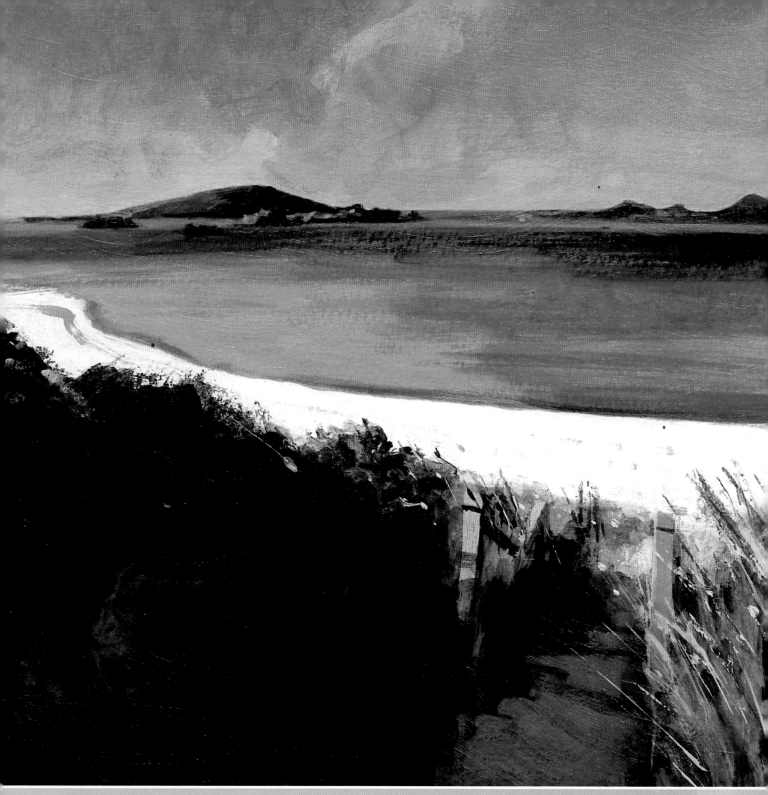

## Smooth strokes

While I was painting this the breeze picked up – the weather was on the change. To reflect this change in atmosphere, I used a dragged brush technique to lay a slightly broken turquoise layer over the deep blue sea. The dragged brush gave me a broken effect, perfect for catching the breeze. These are gentler, calmer mark-making strokes; the sea has not yet broken into waves, but the rippled surface is no longer perfectly still.

### Tresco Path

*Another way to capture the breeze was to flick opaque grass and reed stems onto the green foreground foliage.*

## Dragged brush

A technique that makes the most of the texture of the painting surface, this gives a great broken line which is ideal for suggesting the sparkle on water, or distant waves. It can also be used for texture on mountain paths or foliage.

It is important that you have very little paint on the brush for this technique. Wipe off the excess on some spare rag or kitchen paper if necessary.

**1** Lay in an area of slightly diluted paint and allow to dry almost completely.

**2** While there is still a little 'drag' to the drying paint, load your brush with a small amount of undiluted paint. Draw the brush slowly and evenly across the underlying area of drying paint.

## Wrist flick

This is perfect for textures and shapes that need energy and lift, such as grasses or branches. Feel free to adjust your position – or that of the picture – if it helps you get the perfect angle.

**1** Load a small flat brush with a little paint – just like the dragged brush technique above – and hold it behind the ferrule. Turn the brush so that one of the corners points at the surface.

**2** Twist your wrist down sharply to flick the point of the brush lightly across the surface, leaving a streak of paint.

### Ullswater

*The water in this painting was created using watered-down acrylic paint, which helps to give a mirror-type surface to the sea. This effect helps to give the impression of a very calm, almost still surface.*

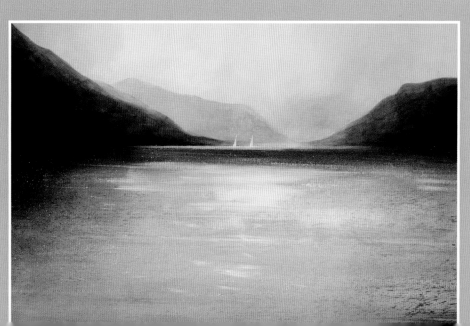

# Breakthrough

Several techniques have been utilised in this image to endeavour to capture the speed, drama and excitement of breaking through a wave. Impasto whites in the foreground help to give depth, while fine, stamped lines create scale and flicked paint creates energy and movement. All of these marks are made with looseness in application, in a deliberate attempt to imply a feeling of speed.

This is all about helping you make a breakthrough in your painting – to start loosening up and producing big expressive shapes and marks with your paints.

**The finished painting**

## Stage 1:
## Preparation and capturing the scene

For me, working from life is what it's all about. You just can't beat the magic that happens when you observe your subject from life. It's a kind of magic, a play-off that is difficult to recreate from a mere photograph. Of course sometimes it is nearly impossible to work from life, so I sketch obsessively, take notes, record sounds and take photographs. The experience of working from photographs is always enhanced when we also have written notes to refer to, or recorded sounds to take us back to the moment. Sketchbooks, journals and collected ephemera become a key part of our process.

Using my 'capturing' process when painting yachts can, I must admit, be a little difficult. But recording the sound of the breaking waves, the crash of the bow as it cuts through the water, and the excited shouts of the crew helps enormously. Add to this some thumbnail sketches and written descriptions and I'm set up about as well as I can be.

## What you need

60 x 60cm (23½ x 23½in) square of mountboard

Brushes: size 12 flat, size 2 round

Paints: French ultramarine, titanium white, cadmium red, burnt sienna, phthalo blue and cadmium red

Pencil, eraser and ruler

Painting knife

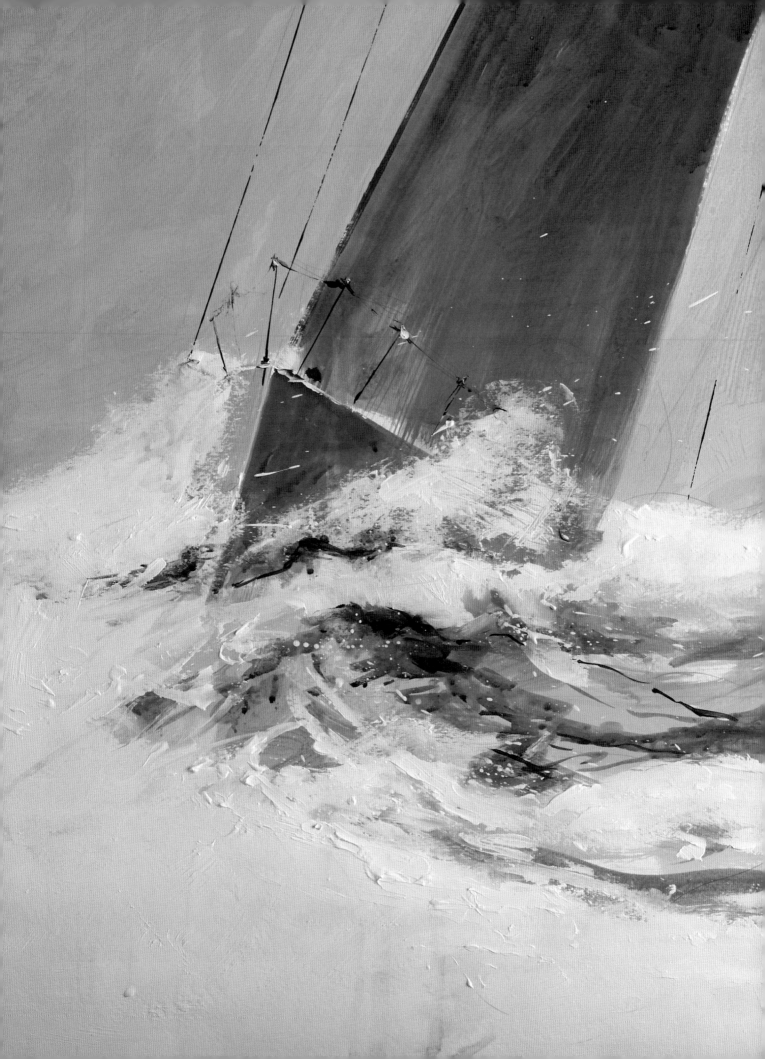

# Stage 2:
## Laying out the colours

Start by sketching out the basic shapes using a pencil. You might find it handy to use the pencil and ruler to add a grid to your paper in order to help square up your image.

Squeeze French ultramarine, titanium white, cadmium red, burnt sienna and phthalo blue into your palette. For the sky area, make a creamy mix of titanium white and phthalo blue. Apply it fairly flatly across the top of the picture, aiming to keep the texture even so that the eye is not drawn to this area, which is less important to the finished picture than the sea.

Using the size 12 flat brush, add some choppy strokes in the sea using the same mix. In the finished picture, this will help to bounce the eye around and give a sense of dynamism to the sea.

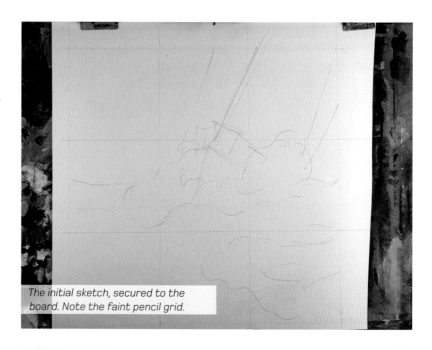

*The initial sketch, secured to the board. Note the faint pencil grid.*

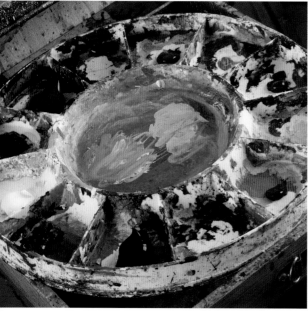

*The colours used at this stage, laid out in the palette. The central area is used for mixing; and you can see the initial mixes present.*

### The painting at the end of stage 2

*Compare the strokes in the sky with those in the sea and note the way the brush is held for the smaller, looser marks in the sea. The sky is laid in using a more controlled stroke; though it is still fairly quick.*

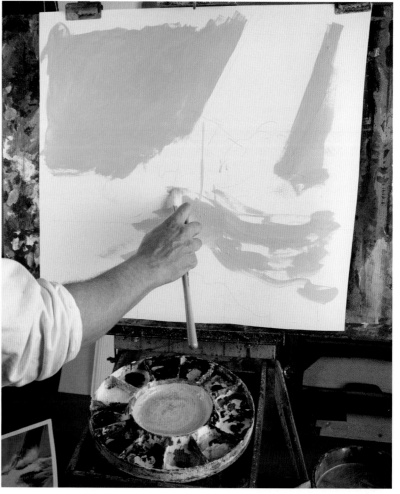

# What else could you do?

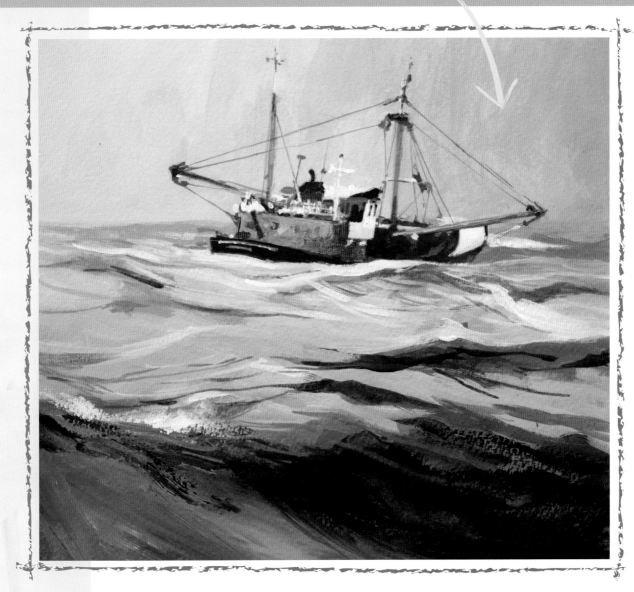

Moving Away

## Different composition

In *Breakthrough*, the step-by-step example, we use heavy-bodied impasto paint and an 'in your face' composition, one that swamps the viewer. Compositions such as these convey drama, speed, and excitement.

An alternative would be to paint the boat sailing away from us, as with the example above, where we see the trawler's stern. This compositional approach is much calmer in feel. Maybe making the subject smaller adds to the gentleness of the new composition? How about less impasto work, if any? How about adding collage elements?

## Stage 3:
# Shaping

Add more French ultramarine to the mix, and block in the boat and sail with the size 12 flat brush. Vary the mix by adding more water, or more phthalo blue, titanium white or French ultramarine paint. Use strokes that follow the planes of the objects, so vertical strokes for the sail and horizontal ones for the boat. Again, add touches of the mix to the sea area with choppy strokes.

Apply pure titanium white to the sea using the same brush. Cover the whole area and create texture by varying the brush stroke direction, angle and length. Try to vary the way you hold the brush to get an almost chaotic feel, and enjoy recreating the movement of the waves and water. The aim is to recreate the energy of the sea – work until the paper is covered, painting intuitively.

As soon as you think 'what now?' this stage is completed.

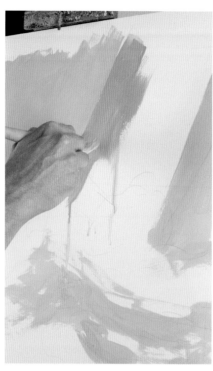 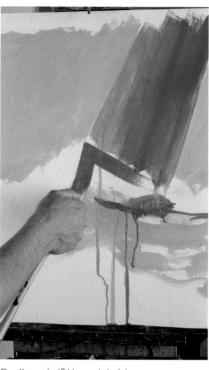

*Long upright strokes are used for the sail.*

*Don't panic if the paint drips – we can cover or use these marks later.*

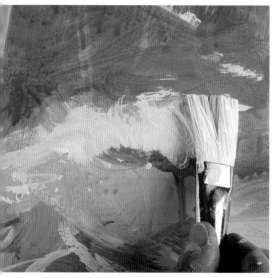

*Roll the brush to create loose, broken marks.*

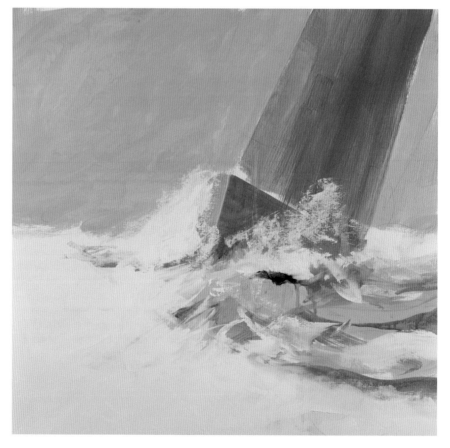

**The painting at the end of stage 3**

*The basic shapes of the boat, the sky and the sea are now in place.*

# What else could you do?

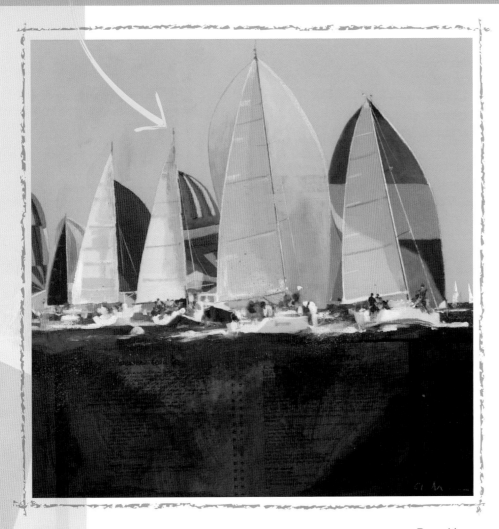

Regatta

## Creating collage

Using a wetter acrylic paint gives us a flatter finish. This is perfect for using with collage materials like coloured boxes cut from magazines, as the wetter paint allows the shape, colour and text of the collage to gleam through. Collage materials can simply be cut out and stuck on using a glue stick.

The sails in this example set up a repetitive composition, a swaying motion, lulling the viewer. The bright colours used in the sails draw the eye into and across the picture plane from left to right, picking up interest and detail along the way.

## Stage 4:
# Shadows and light

Burnt sienna, like other earth colours, will mute and neutralise other colours. We will use this quality to add some interesting dark tones and modelling to the boat and waves.

Mix phthalo blue and burnt sienna together and dilute a little to a watery consistency. Still using the same size 12 flat brush, use this mix to glaze the sails; then use the corner of the brush to add touches of this darker tone to the sea on the left-hand side.

Use your fingers to add undiluted titanium white to the foreground, creating thick, creamy texture which helps suggest detail. This also creates distance, by adding contrast in texture between the foreground and the boat. Dilute the white paint to a milky consistency, dip your fingers into the well and flick it around the foreground to create energy.

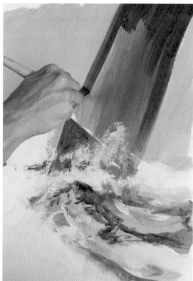

*The burnt sienna and phthalo blue mix is diluted to a watery consistency.*

*Glazing the sails deepens the tone.*

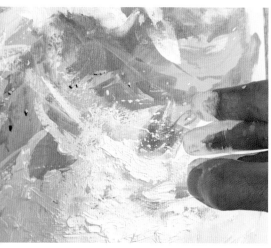

*Flicking paint gives a fantastic spattering effect – I love a bit of flickety-flick!*

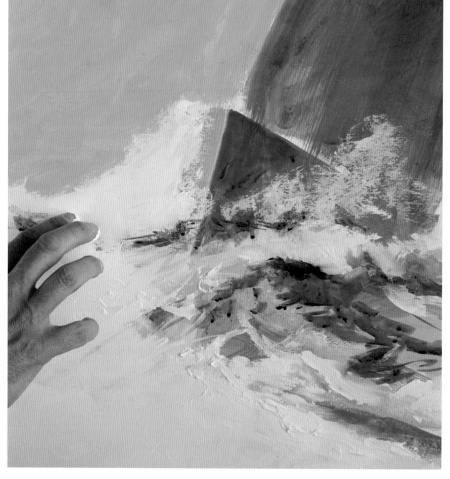

### The painting at the end of stage 4

*A few touches of pure titanium white paint add texture to the breaking wave, suggesting the sea foam and energy.*

# what else could you do?

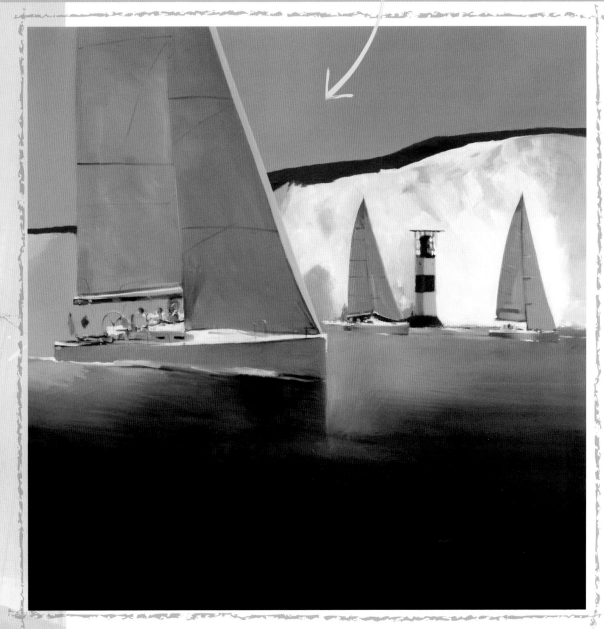

Yacht Race

## Complexity

Movement in a painting can be created in many different ways, from changing the overall composition to changing the light source. In the above example, an element of slick speed is introduced by using sharp lines, shadows and crisp highlights to cut through the otherwise softly painted background and sea. The defined outlines are accentuated by using silhouette sail shapes against the white cliffs and crisp whites on the near yacht. Flickety-flick is kept to a minimum to avoid overworking.

## Stage 5:
# Details

Using the burnt sienna and French ultramarine mix, straighten the edge of the sail by drawing a size 2 round brush down it – the background sky should be dry by this point, so you can rest a straight edge against the surface to help. Paint the edge of the ruler with the same dark mix and use it to stamp the surface just to the left of the sail to suggest rigging.

Add tiny areas of shading to the blue parts of the sea with the tip of the size 2 round and the dark mix of phthalo blue, French ultramarine and burnt sienna.

Dip the edge of a small painting knife into the dark mix and use it to draw the other rigging and the guard rail on the front of the boat. If you need to add curves or thicken areas, use the tip of the knife.

*Using a straight edge to guide your brushmark.*

*Printing the rigging using the straight edge.*

*The painting knife makes sharp lines easy.*

**The painting at the end of stage 5**

*The painting is nearly complete now, but is lacking a focus.*

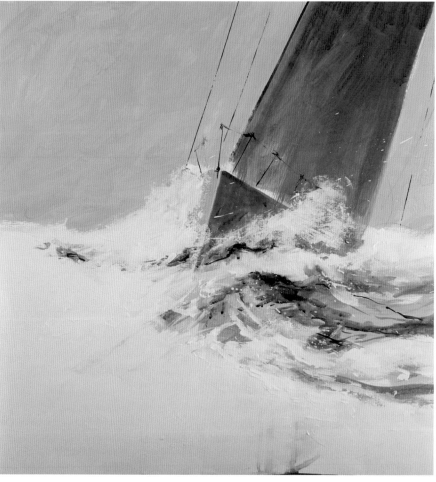

## Stage 6:
# Finishing touches

Add crisp highlights to the boat hull using titanium white and the edge of the painting knife.

To finish, add a tiny hint of cadmium red to the bow with the painting knife. This spot of red will leap forward and catch the eye of the viewer because it contrasts so strongly with the cool blues and whites of the rest of the painting. Try to avoid the temptation to make the red area too large, as this can detract from the effect.

With these in place, make any further adjustments or additions you wish – and then declare your painting complete! The finished painting can be seen on pages 38–39.

*Clean sharp highlights give contrast with the chaotic broken shapes of the sea.*

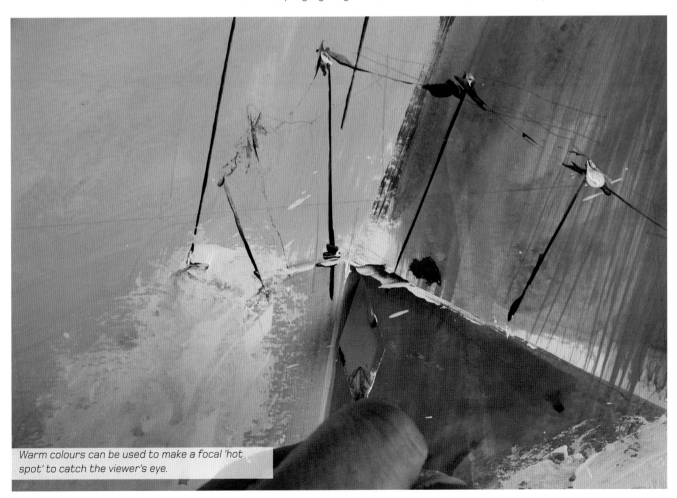

*Warm colours can be used to make a focal 'hot spot' to catch the viewer's eye.*

# What next?

Our sea in *Breakthrough* is a close-up crashing wave, with lots of white water and foam. It's full of energy and excitement. But of course, the sea has many, many moods, and each is as captivating as the last. I have chosen painted examples throughout this chapter to describe the sea in various states, from calm to rough, deep to shallow, night and day.

I would like you to have a go at the tutorial painting on the previous pages, but more than that, I would really love you to experiment with sea paintings. Use the examples shown here and throughout this chapter to work out how they can apply to your location and situation. Is it possible to change the atmosphere of a scene simply by using a different colour palette? Can we enhance the drama of a seascape by altering the composition? Try languid, loose strokes for gentle seas or manic, energetic, furious mark-making for excitement.

## Fleet

*You will notice an element of collage in this painting. This was used to amplify the 'depth' of the sea, to create mysterious shapes and interest. This collage material has also been placed in a common inverted triangle composition, before being glazed over with a watered-down cerulean blue. Just a touch of heavy white has been used to create the sparkle and to draw the eye to the main area of interest.*

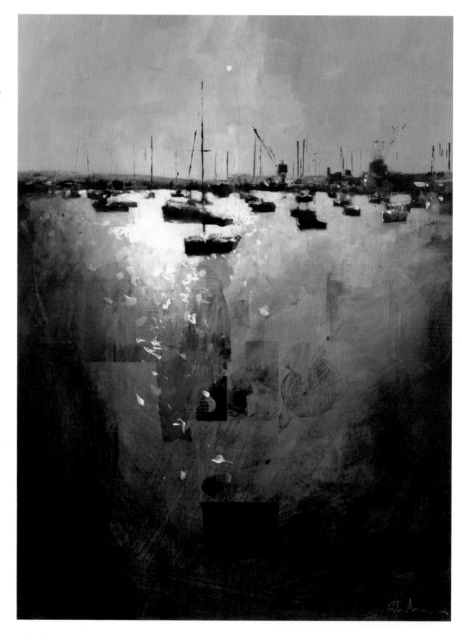

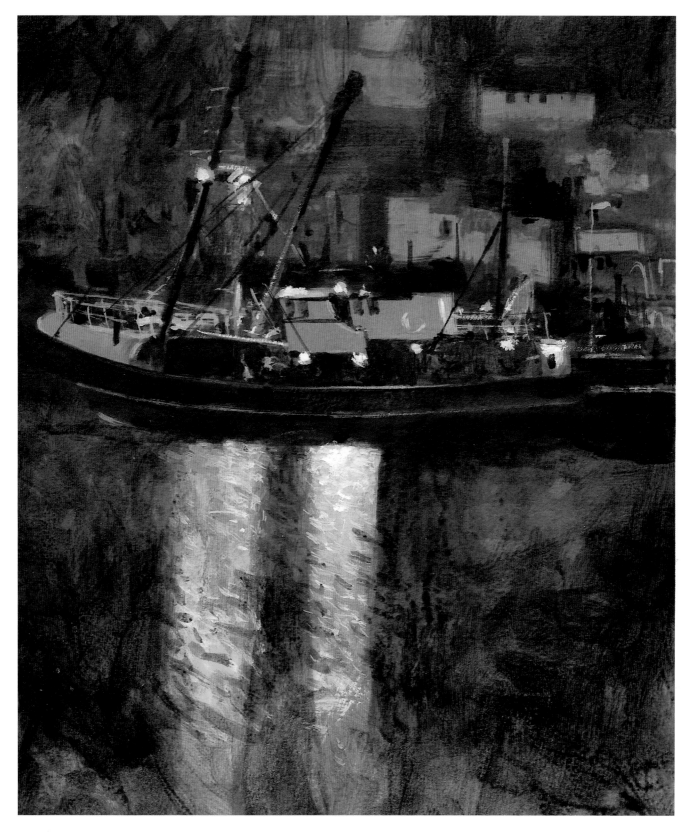

## Trawler

*This trawler, slower and heavier than the racing yacht in the project, is set off by a brooding, darker atmosphere. This was created through the use of generally dark tones with bright piercing lights and reflections to give great contrast. This, along with the angles of the masts, adds a dynamic feeling to the painting while still portraying a calm sea.*

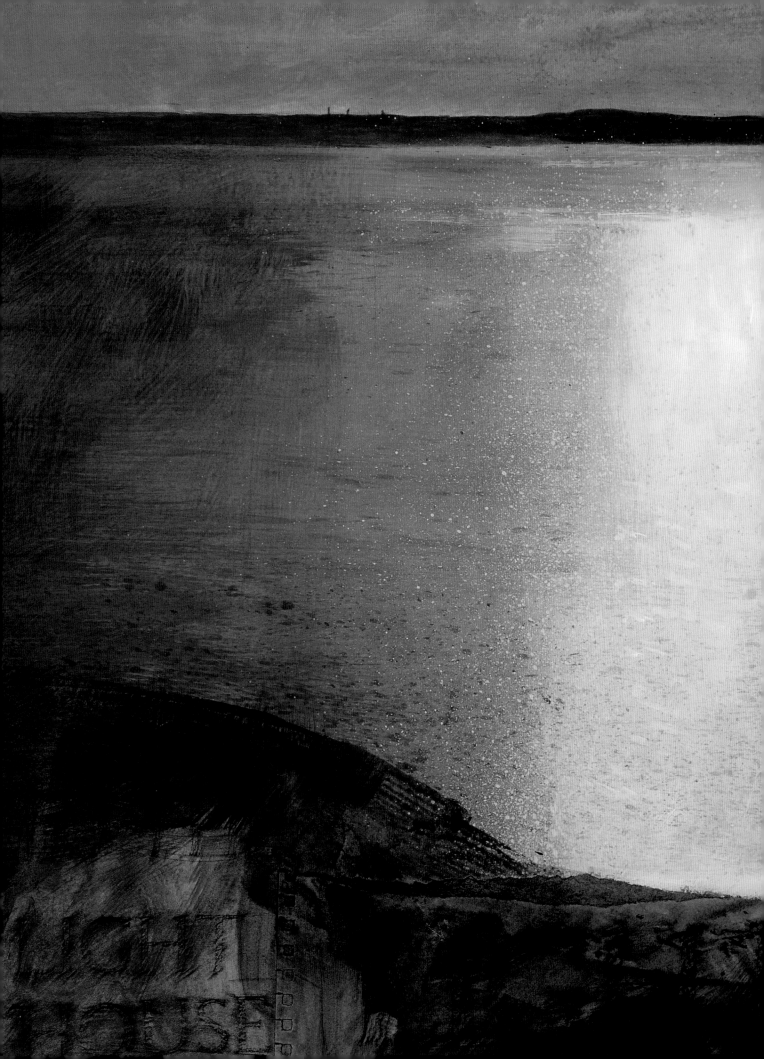

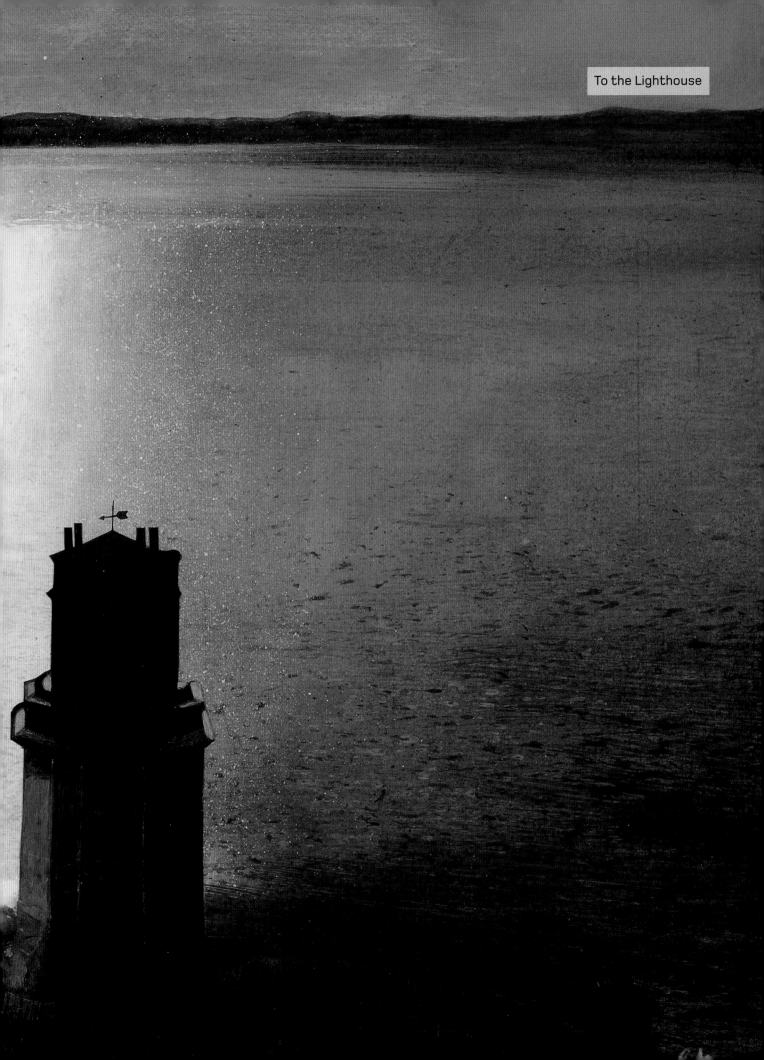

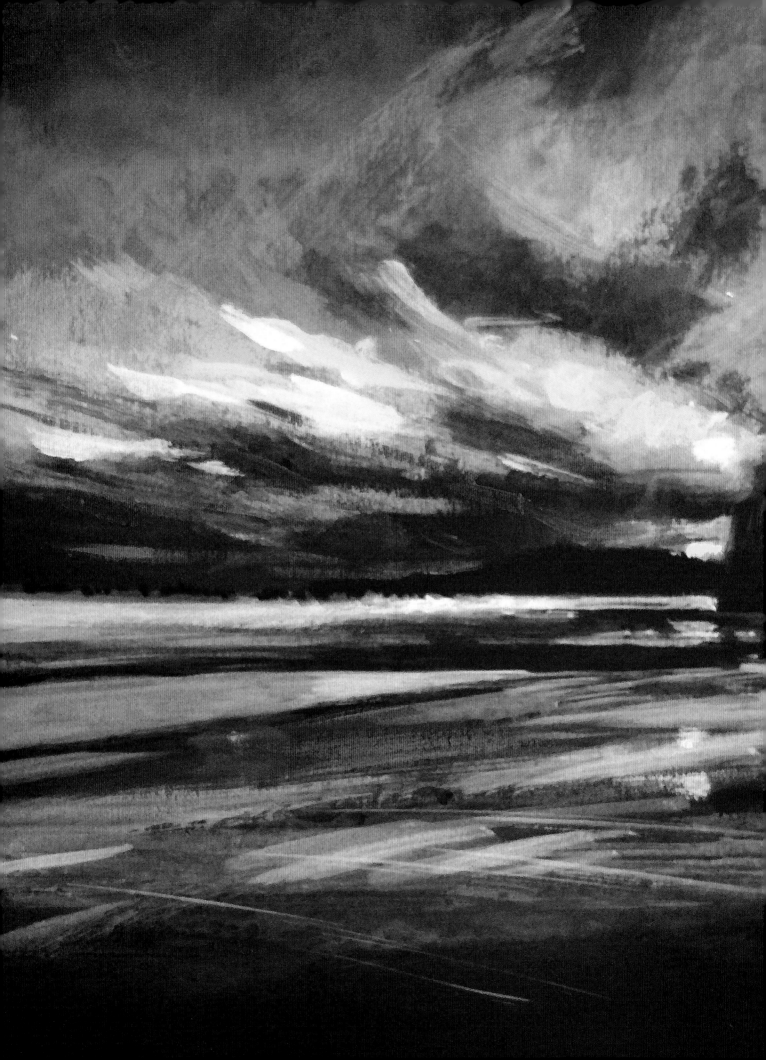

# LOOKING UP

Western Shore

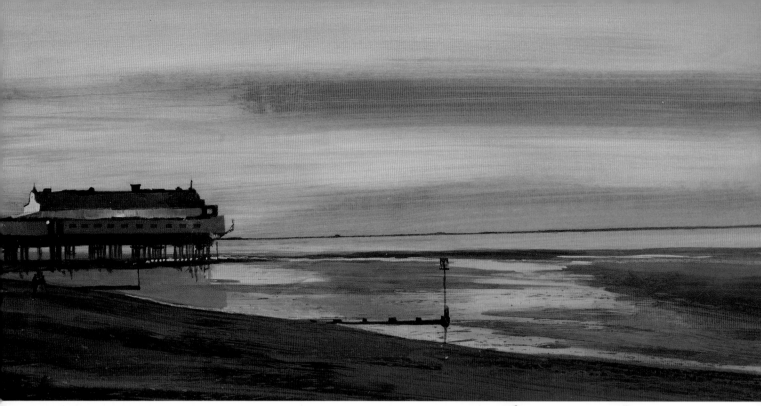

# The sky

The sky, the sky, where do you start? Endless blue, cloudless, summer skies; a sheltering cobalt as far as the eye can see – or a slate grey, Victorian blanket; oppressive, unforgiving, leaden. The sky can be filled with the fire of a victorious sunset, a Turneresque blaze of sparkling saturated jewels – or suffused with the soft optimism of a breaking dawn; pale rose and lemon with cinnamon whispers of gentle cloud.

Inky blue, powder blue, harvest gold, bible black – in fact, all colours. How do we capture the sky in all of its varying moods?

*Top:*

### Sunrise Pier

*This large sky uses a simple mix of cadmium yellow and cadmium red. These colours appear even more intense set against the purples and blues of the pier and beach.*

*Left:*

### Winter Beach

*In contrast to the vibrant summer painting above, this winter scene was painted with sponge work and watery paint to more accurately describe the glassiness of the chill winter sky.*

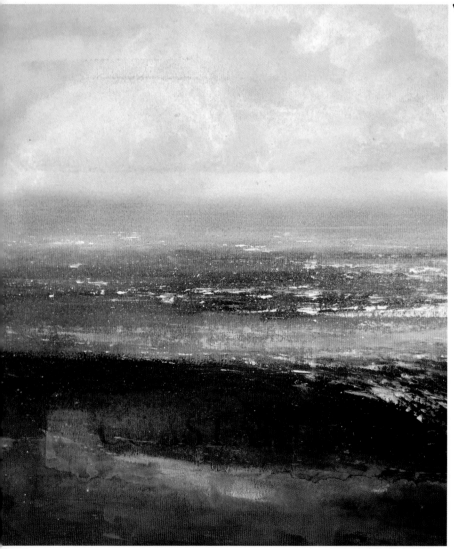

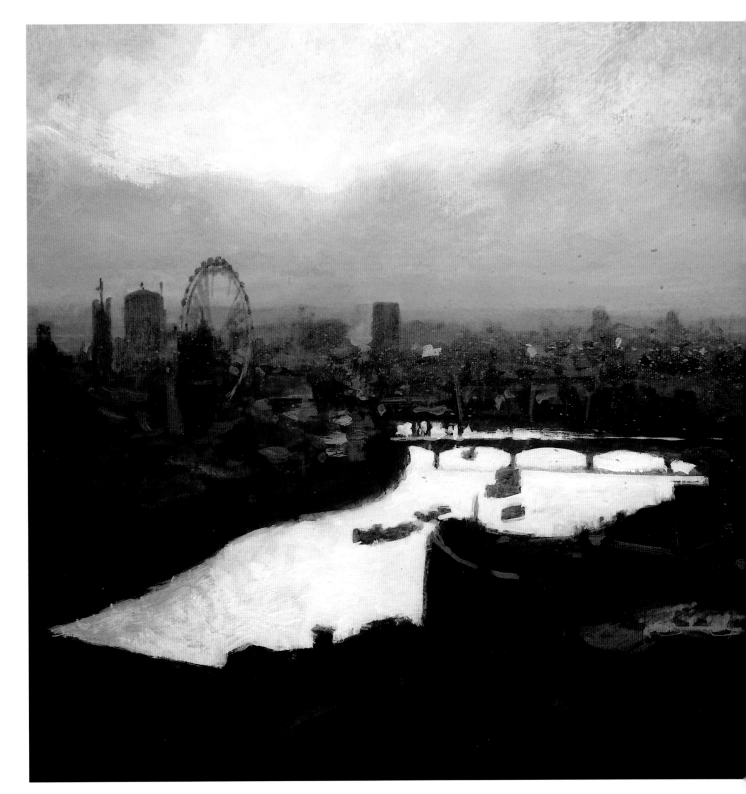

**Thames Air**

*The pinks and yellows in this London sky were softened with titanium white, both mixed into the neat colour and glazed over the coloured surface once it had dried.*

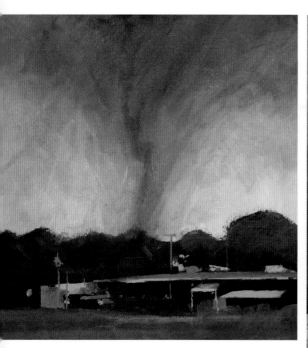

# Opportunities and challenges

The sky affects all other elements in a landscape, from colour, light source, tone and atmosphere. It is the sky and the light from the sun that creates our atmospheric winter silhouettes and dramatic summer shadows. The famous landscape artist John Constable (1776–1837) knew this and always focused his attention on the sky when beginning a painting, saying: 'The sky is the source of light in nature and governs every thing.'

Just like the sea, skies are constantly changing. Think about the weather. Still? Cloudy? Hot? Raining? Stormy? How do these elements affect the colour, the atmosphere and the mood of the scene?

With these considerations in mind, this part of the book focuses on sky colour and sky effects and how we can use them to our advantage, as well as giving specific, practical techniques to produce convincing paintings of the sky in all of her moods.

*Left:*
## Tornado
*Watered-down colour was applied wet into wet with a sponge to create the swirling mass of the passing tornado.*

*Centre:*
## Mid West Skies
*Dark Prussian blues and Payne's gray were applied over a basic wet-in-wet sky. These 'neat' colours were allowed to mix in naturally. The final stage of this stormy sky was to rub neat titanium white into the surface with my finger.*

*Right:*
## Porthcurno
*This sky is painted using 'negative' space. That is to say that the dark cloud areas were painted first, followed by the paler blues and lemon yellows. Using white together with the blues and yellows made the mixes opaque, which gave me the ability to paint colours over the dark clouds, changing their shape where necessary.*

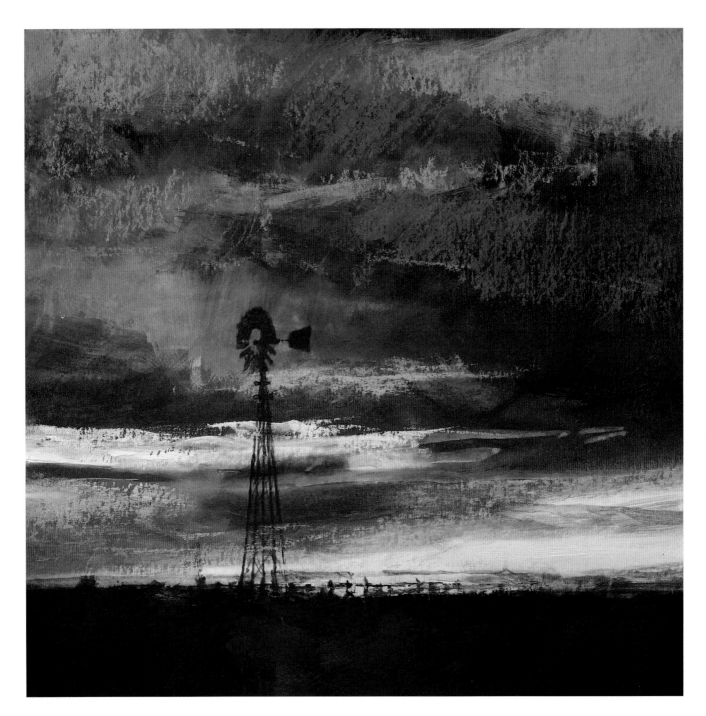

## Texas Sunset

*A dramatic sky calls for a more dramatic approach. For this painting I ramped up my choice of colours and techniques by adding conté work over the acrylic paint. Conté sticks, pastels and soft pencils all work well with acrylic and can add extra textures and powerful mark-making options to our work.*

# Useful equipment

Painting the sky requires much the same equipment as the sea, so everything you've used there applies here, too. Grab the same brushes, surfaces and paints as before, and you're ready to go. If you fancy experimenting more, then try some of these additional tools and materials to help create fantastic skies.

### Roller

Rollers are great for adding fast, spontaneous, large areas of colour – perfect for skies. My favourites are inexpensive 'radiator rollers' which have a long handle and a small foam roller head. The foam heads simply pop on and off to clean or replace. You can find them at most DIY stores.

### Painting knife

These little beauties come in all shapes and sizes and are perfect for both spreading impasto paint onto our surface and for adding detail where necessary. I often use a small diamond-shaped knife (as seen above). Palette knives can also be used for the same techniques.

### Acrylic mediums

From fluid gels to heavy impasto gel, a whole range of fantastic acrylic mediums are now available which can be added to your paints to alter their qualities. My current favourite is structure gel, which I use to bulk out my acrylic paint, making it thick and heavy-bodied. Crucially, as the gel dries, the peaks and troughs created remain, leaving great texture where you need it.

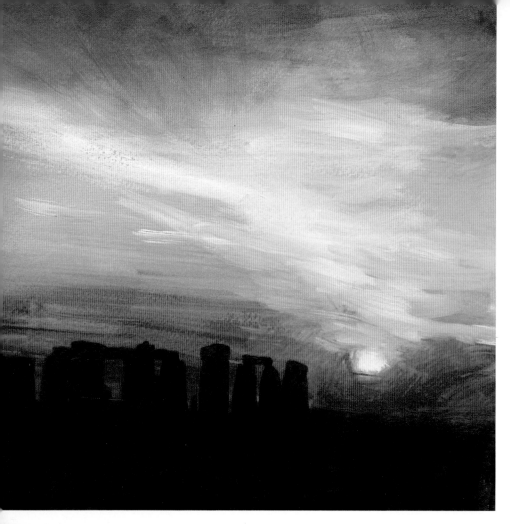

### Stonehenge

*A dominant sky above the ancient ruins of Stonehenge in Wiltshire, UK. All the colour, drama and brushwork revolves around the sky.*

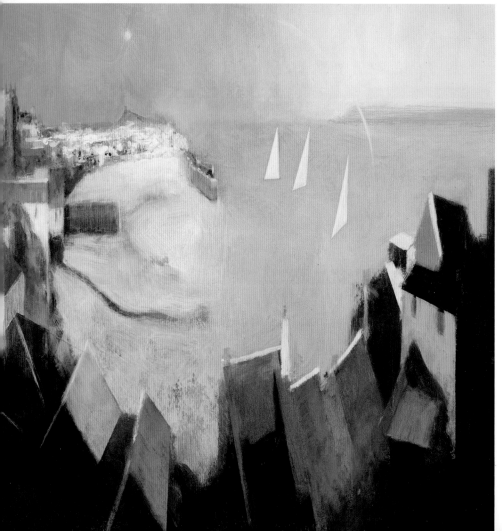

### Beach Light

*A fresh and bright sky that hazily merges into the sea on the horizon acts as the perfect foil to the foreground buildings. Its unbroken smoothness lends the painting a sense of serenity and softens the harder shapes of the roofs and sails.*

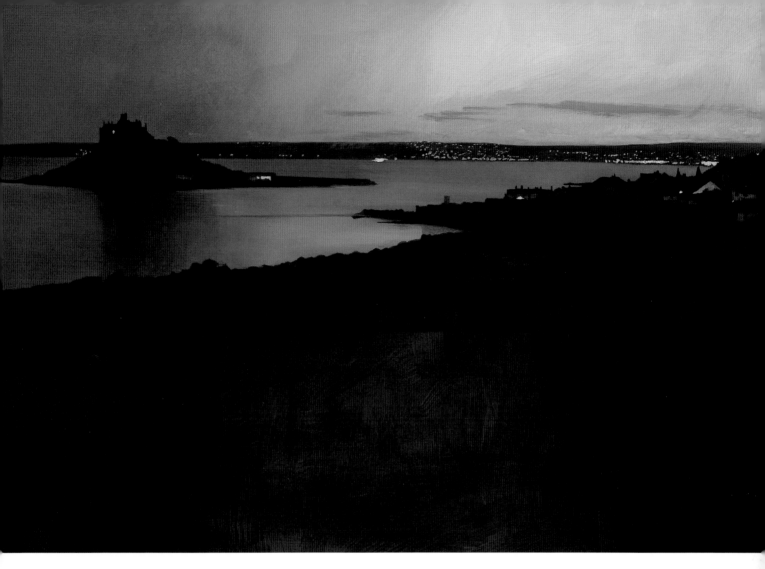

# Colour and movement

## Sunset

*Despite taking up a relatively small part of the painting, the sky in this painting provides interest, colour and light, setting off the brooding land and still sea without letting them dominate.*

Nothing changes our emotions in the way that colour can, and each of us has a personal response to colour. What does an inky deep blue mean to you? Claustrophobia or freedom?

When incorporating skies into our work, we need to ask a few simple questions. Firstly: is our sky the main subject or simply our light source? In other words, is our sky the lead actor with all the best lines, or a supporting actor, still necessary but fulfilling a less important role?

If the sky is our lead actor, then that is where we put our main focus, our drama, our passion. If the sky supports another element in the composition, then less work is needed.

These pages will explain some techniques that are particularly well-suited to creating colour and movement in your paintings, by showing how I used them to paint the skies shown in the artworks on these pages and contrasting them with other finished examples.

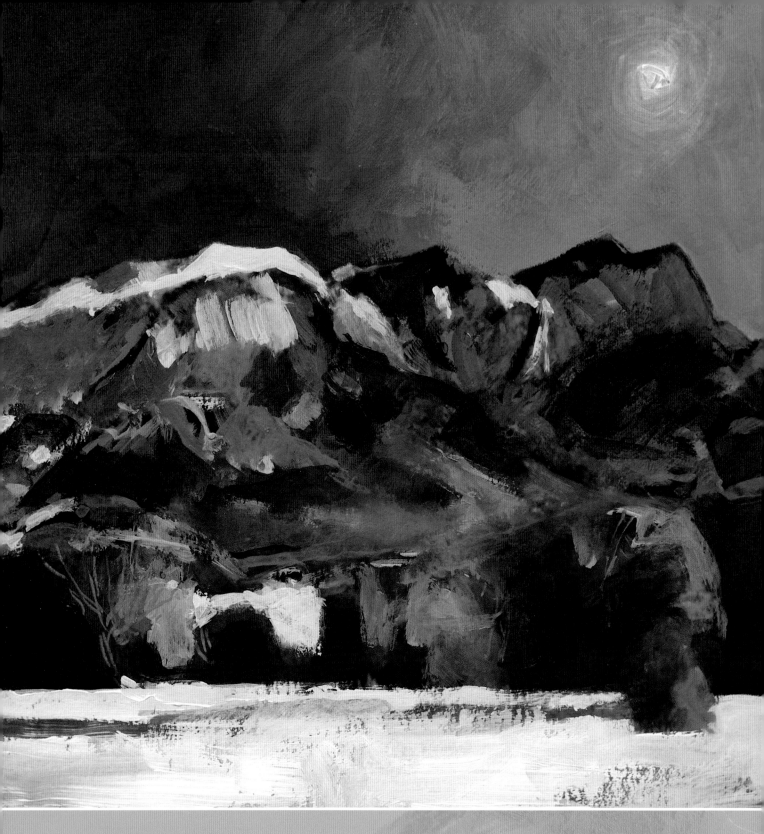

# Light over dark

Painting light over dark is just one of the ways that makes painting with acrylics so much more versatile than most other media, particularly watercolour. It allows for techniques that are distinctly acrylic, with strong covering marks allowing you to work quickly and adapt on the fly.

### Santa Fe Moon

*This painting was made* en plein air *sitting out in the warm desert evening. The lizards there seemed as interested in me as I was in them and kept me entertained over the course of this relatively quick painting. After starting with a deep, dark blue-grey background, I added the mountains and desert floor using a light over dark technique, while the sky was painted using negative painting (see opposite).*

## Overlayering

Starting with a dark background and working to progressively light colours can be very liberating. Used thickly, opaque acrylics will completely cover the layer below, whatever the colour.

**1** Load your brush with paint that is either undiluted or only lightly diluted. Reload when necessary so the light colour 'reads out' over darker underlayers.

**2** The dark underlayer can be used as ready-made shadow – apply your strokes to make the most of the shape.

## Negative painting

'Negative painting' is a technique where we paint the space behind an object, leaving the object itself – in this case, painting the sky behind the mountains. Negative painting allows us to easily change the shape of any object by 'cutting in' with the opaque paint. When using this technique it is important to keep your paint reasonably dry and therefore more opaque.

**1** Instead of painting the object itself (in this case, the mountain), paint the area around it – the background sky in this example.

**2** Work up to the edges of the area and then block in the remaining space.

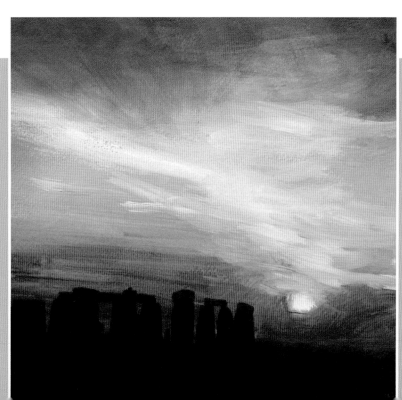

### Stonehenge

*Stonehenge is one of the most iconic and recognised silhouettes in the world, but the real focus of this painting is the midsummer solstice sky.*

*Painted in an exploratory way, darker reds and blues were initially laid over a yellow underpainting. Once it was dry, I began to work 'backwards', adding paler lemons and whites over the darker areas. This approach has two main benefits. The first is that I do not have to get too bogged down with the traditional 'dark over light' approach and can instead move back and forward effortlessly. The second advantage is that glazed darks over lights followed by scumbled lights over darks help to create a sense of space and depth.*

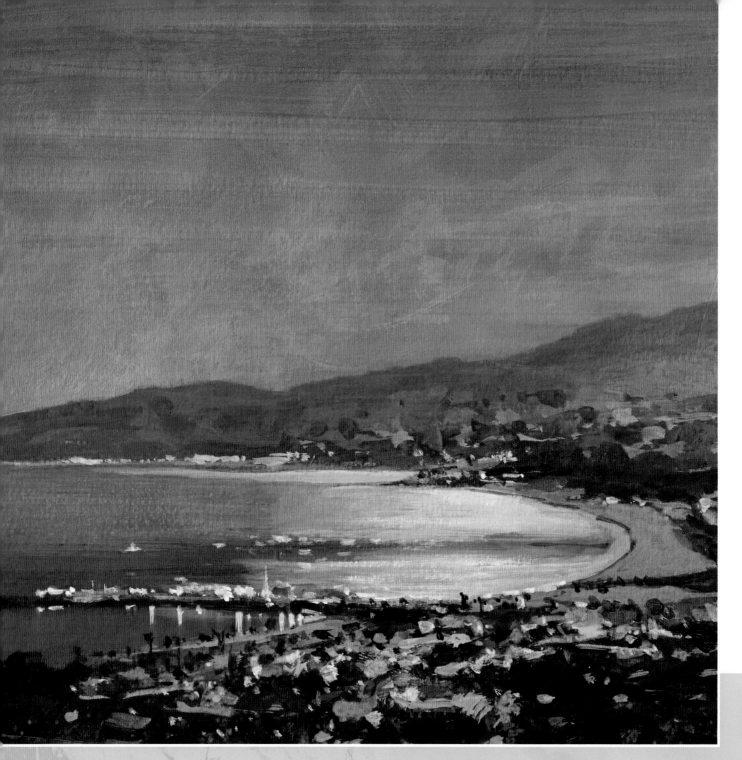

## Peeking through

Scumbling works a little like glazing, in that you paint over an area but can see some of the underlying colour showing through. The difference is that a glaze uses dilute, semi-transparent paint, while scumbling uses dryer opaque paint. The brush deposits broken colour which allows some of the underlying paint to show through, creating vivid effects.

### Santa Barbara

*The southern California coastline is washed by the mighty Pacific Ocean and bathes in some of the most glorious colours that I have ever experienced. Rich purples and pinks appear where only an hour before the mountains were verdant green and the beach white. I used this colour combination to my advantage in this painting, with the pink beach dragging the area towards us while the purple blue of the mountains by default move backwards in the composition, gaining more height and mystery. Simple, gentle touches of pale blue begin to describe buildings and life which, again, help to give a majesty to the mountains and sea beyond.*

# Scumbling

The scumbling effect is heightened on textured surfaces like rough paper or canvas. It is important that the paint is completely undiluted and the brush is bone dry – any wetness will turn the effect into a glaze and lose all the texture.

**1** Load a completely dry brush lightly with paint direct from the tube.

**2** Use a random scrubbing motion to transfer the paint from the brush to the surface over the area you want to scumble. Note how small areas of the underlying colour show through.

*Scumbling was used to add texture and interest to the sky by layering blue and pink over a yellow base coat of paint. For multiple layers of scumbling, always make sure everything is dry before you start.*

### Beach Light

*Scumbling can work equally well with paler or darker colours. For example, the sky in* Santa Barbara, *opposite, was scumbled with the stronger cerulean blue over the paler yellow and rose pink; while the sky here was painted in blue, with neat titanium white scumbled in from the right-hand side until my brush ran out of colour.*

*Using this scumbling process gives us really fresh-looking results and works well when painting the sea, buildings and foliage. When scumbling, remember to allow the underlying colours to dry completely, or you risk ending up with a painting full of muddy colour!*

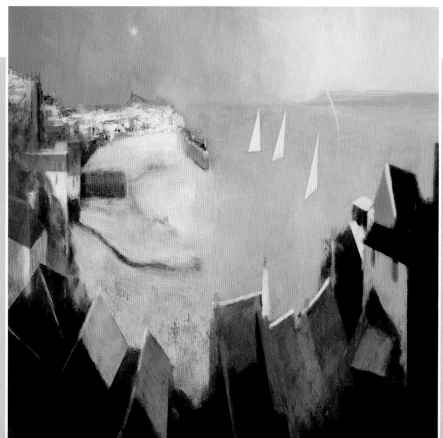

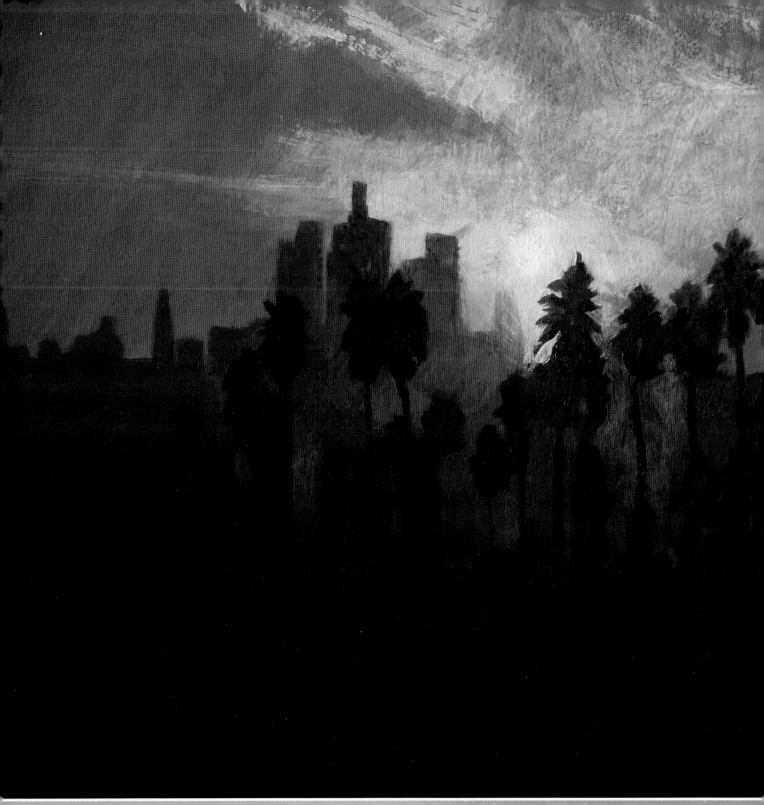

## Using a limited palette

Using twenty colours on a painting will usually end up with either a Disneyesque-coloured harlequin of a painting or a palette full of muddy mixes. It is far better to choose just three or four colours to work with. Painting becomes easier and our creative artwork becomes more successful.

Picking a limited palette helps with the overall unity of the finished work, gives less visual clutter, and makes for an easier painting process.

**L.A.**

*Using scumbling techniques as well as negative painting (see pages 65 and 63 respectively) makes best use of the limited number of colours. You can best see the negative painting process around the palm trees immediately in front of the sun. Also note the dry, dragged brush work using cadmium yellow over cadmium red in the sky.*

# Restricted colour palette

Using colours is akin to choosing ingredients when cooking. If we opened the refrigerator and pulled out every single ingredient, it would be really difficult to make a successful meal using all of them. It is far better to use three or four carefully chosen ingredients for a successful dish. Well, the same goes for colours. If we squeeze out twenty colours and set to work, it can be very difficult to control not only colour but just as importantly tone.

Paintings like *L.A.* and *Sunset* use a very restricted palette of carefully chosen colours. In the case of *L.A.* these were cadmium yellow, cadmium red, a touch of titanium white and French ultramarine to mix a dark for the silhouetted foreground. The important thing is to make sure you can get the lightest lights and darkest darks you need through mixing the colours, so that you have the full range of tones at your fingertips.

*The sun is the brightest point. The yellow and white sun burst was painted by 'cutting' around the dark red trees with negative painting.*

*This detail of the foreground shows the dark mix – made of ultramarine and cadmium red.*

## Sunset

*Using a limited palette is one of our most powerful tools, and one that can really give our creative artwork extra punch.*

*Carefully chosen limited colours can really set the mood of our painting, as can be seen in the examples shown here and opposite. Both were painted at the same time of day, but one is a hot summer Los Angeles evening, the other a chill Cornish winter evening.*

*I really recommend experimenting with just two or three colours in your creative endeavours. Not every combination you choose will work every time, but when they do it is a hugely exciting moment, and one that you can call your own.*

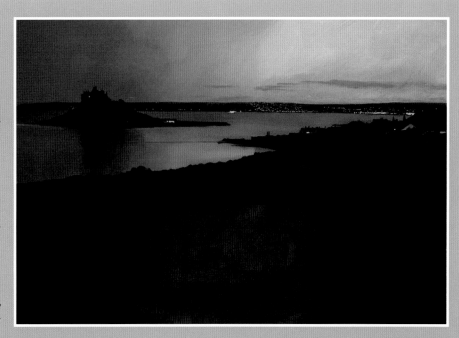

# Summer's End

This demonstration painting uses vigorous techniques that are easy to adapt to other subjects. The roller work, for example, works just as successfully when painting the sea, mountains or fields. The impasto foreshore technique is ideally employed when painting old stone walls, barns and rustic buildings.

If you study the examples in this book, you will find these ideas used in a whole variety of ways, on a variety of subjects. Adaptation to your own style is key.

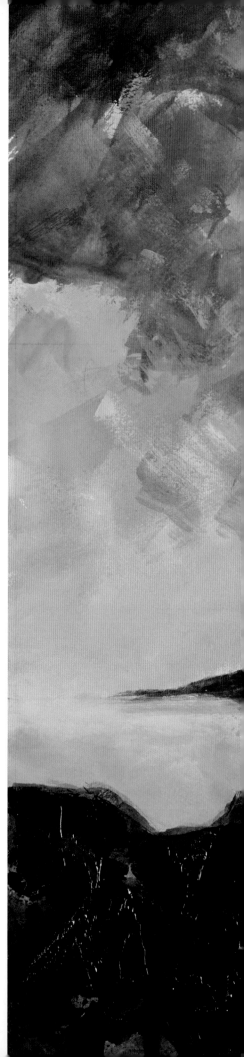

**The finished painting**

## Stage 1:
## Preparation and capturing the scene

Capturing the fleeting beauty of the sky can be really difficult. Sketches can help to describe an impression of the wind, clouds, light and darkness. But a pencil or pen alone is often not enough – and for me, photography can only help so far. My shots only ever look like pale representations of the sky scene before me. My favourite way to start 'capturing' a sky is with words. Please don't get me wrong, I'm certainly no poet! But sometimes a list of colours, descriptions and shapes can more accurately sum up the sky than one of my insipid photographs.

If I write that a sunset is a 'fiery Turner sunset', I can picture that sky in my mind in full, glorious technicolour. I'm willing to bet that you can too. How about phrases like 'a leaden grey sky, still apart from a murmuration of black starlings, dancing effortlessly', or 'three wispy white clouds floating gently in a rich sky, velvet purple above, cobalt blue on the horizon'?

For this particular skyscape, my notes read: 'Sky ablaze with Hockney colour, deep purple over pale cobalt. Lemon, cadmium, scarlet, silhouette Mount. Canada Geese fly over the mount, a perfect V cawing their way into the distance. A curious mix of Vivaldi's *Spring* and Blur's *To the End* on my mind. Roast hake and a pint of Tribute up next...'

## What you need

60 x 60cm (23½ x 23½in) square of mountboard

Brushes: size 12 flat, size 2 round, size 4 flat

Paints: Winsor violet, cadmium yellow, cadmium red, permanent rose, burnt sienna, titanium white and brilliant blue

Pencil, eraser and ruler

Roller and spare heads

Painting knife

Heavy structure gel

Small piece of scrap cardboard or spare mountboard

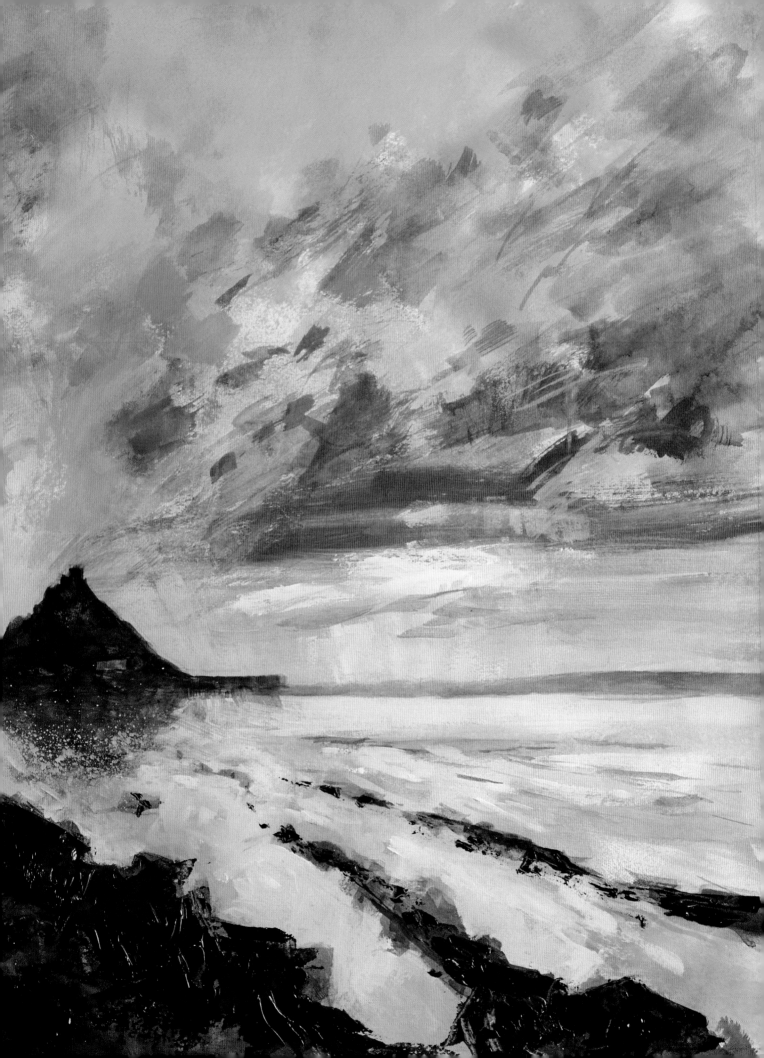

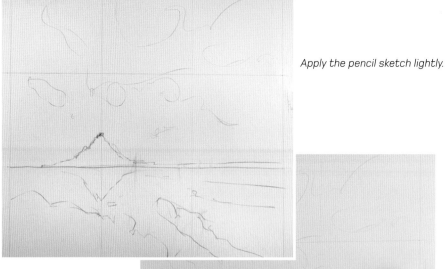

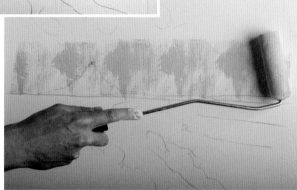

*Apply the pencil sketch lightly.*

## Stage 2:
# Warm colours

Add a grid with the ruler and pencil, then sketch out the basic shapes of the beach, distant hill and clouds on the mountboard, then prepare your palette with Winsor violet, cadmium yellow, cadmium red, permanent rose, burnt sienna, titanium white and brilliant blue paints.

Using a small roller, add a broad stroke of cadmium yellow across the top of the horizon, then build up the area in the centre. Add reflections below the horizon with a second stroke.

Touch the end of the roller into permanent rose and add strokes that radiate out from the centre into the sky and sea. Do the same with titanium white wet-into-wet.

*The horizon line can be used to guide your first stroke.*

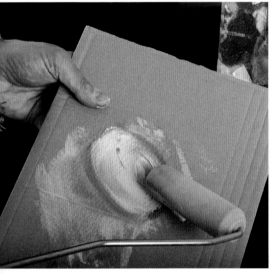

*A sheet of cardboard makes an effective temporary palette.*

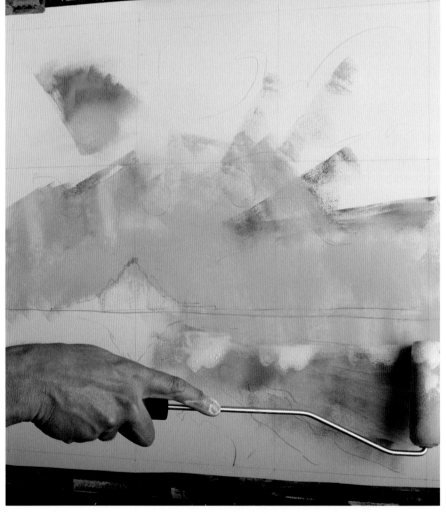

### The painting at the end of stage 2
*The yellow area covers the central third of the painting. Note that I have worked right over the pencil lines of the mountain.*

## Stage 3:
# Adding contrast

Change the roller head and apply a mix of brilliant blue and titanium white to the upper part of the sky and the lower part of the sea. Use the central area of yellow as a focal point and add strokes in the lower part on the sea. Leave some areas of the mountboard clean, as shown.

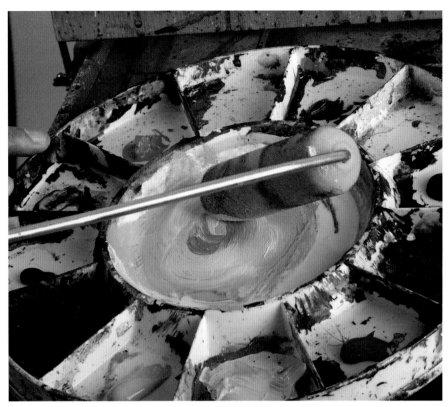

*There's no need to blend the colours together completely in the mix – slightly more blue or white in areas increases interest.*

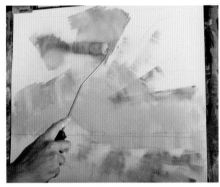

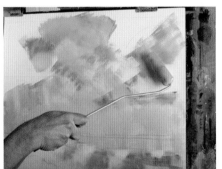

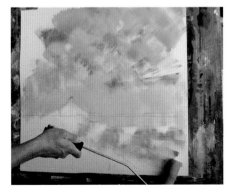

*Apply the blue in strokes radiating from the central yellow area.*

### The painting at the end of stage 3

*Contrasting bright colours make this painting vibrant and fresh-feeling even at this early stage.*

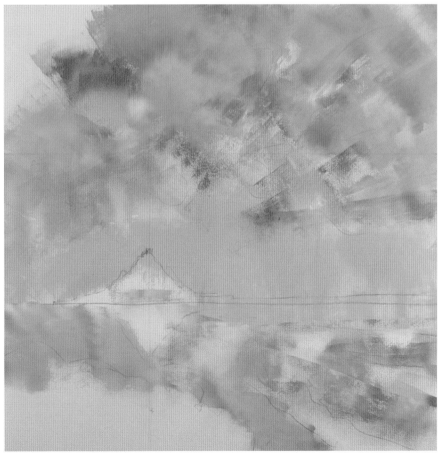

## Stage 4:
# Completing the background

Add a little permanent rose to Winsor violet, then add hints of brilliant blue and burnt sienna. Dilute this dark mix and use it with loose scrubbing motions of the size 12 brush to begin to add dark touches to the upper part of the sky. Radiate them out from the area of clean mountboard in the centre (this will be St Michael's Mount, a tidal island in Cornwall).

Rinse the brush and apply cadmium red in loosely horizontal strokes across the middle of the sky. Around the centre, loosen the strokes to lead the eye towards the focal point by creating a sense of movement.

Continue building up dilute strokes across the painting with the same colours. Whatever colour you add to the sky, add to the sea as well – use the horizon line as a dividing line. If the colour is at the top of the sky, the colour will be reflected in the sea at the bottom of the painting.

 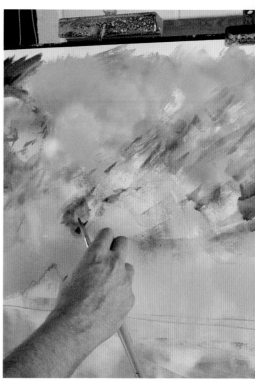

*Concentrate the dark areas in the corners and in the white spaces that you left earlier.*  *Use the corner of the brush to add the smaller dark touches.*

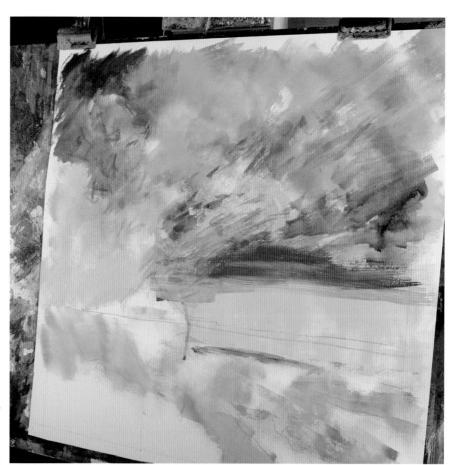

**The painting at the end of stage 4**

*All of the lines converge on the focal point – that is, St Michael's Mount.*

# What else could you do?

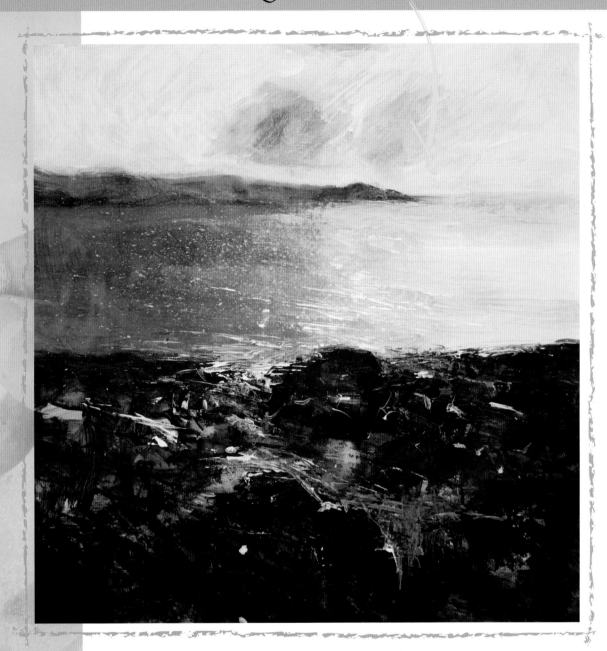

Cornish Winter Sky

## Rag application

An alternative that I use often when painting skies is to use a rag technique. Applying paint with a scratchy rag allows a wonderful scrubbed surface, which can lead to a gleaming scumbled effect, bouncing the light around.

In this example, titanium white was applied straight from the tube with an old rag, rubbed into the painting surface over an already dry wash of dark blues and greys. Creating instant interest and texture, this technique can also be used successfully for weathered surfaces such as old wood, stone, dry grass and sand. Remember to allow underlying colours to dry completely before working over.

## Stage 5:
# Adding texture

Build up the colour in the middle part of the sky by using the flat of the size 12 flat brush to apply creamier, thicker mixes of titanium white and cadmium yellow. Use strokes that lead towards the focal point.

Paint in the island and reflection with choppy strokes of burnt sienna applied with the same size 12 flat brush. Use your fingers to add looser texture to the reflection by tapping the wet paint.

Still using dilute burnt sienna, build up the remaining land in the foreground. As with the sky, lead the eye towards the focal point of St Michael's Mount by building up lines that point towards it.

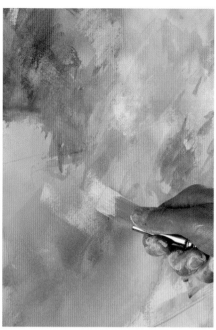
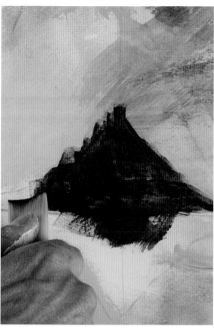

*Hold the brush near the bristles for control.*     *Choppier marks suggest rocky textures.*

*Dappled marks are quick and simple to make with your fingers.*

**The painting at the end of stage 5**

*The addition of the earth-coloured land areas begins to make sense of the background.*

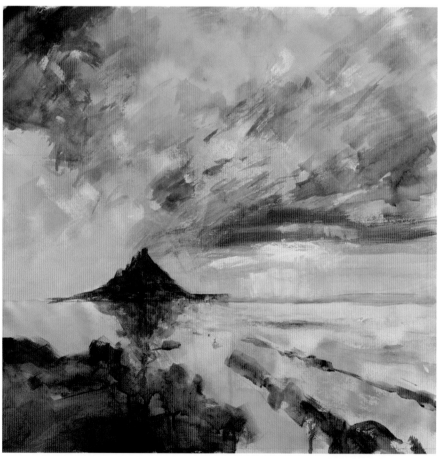

# What else could you do?

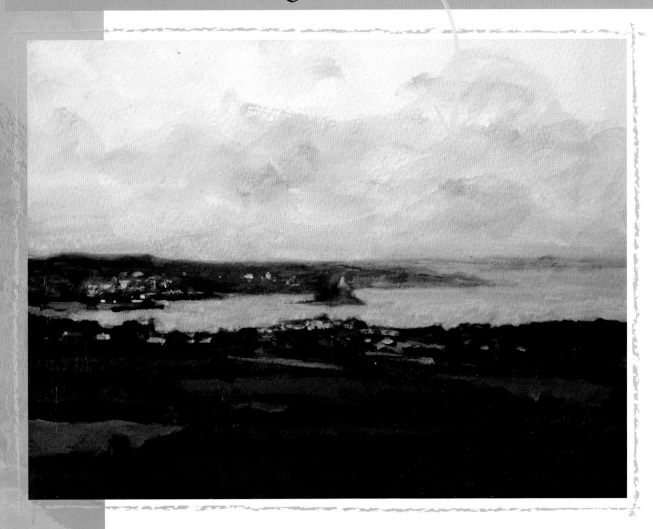

## Finger painting

While you should be childlike in your painting and enjoy experimenting, there is no reason that this technique should be dismissed as childish. More than brushes, sponges or any other ways of getting paint on the surface, your fingers are a fantastically sophisticated tool for painting.

As well as being a lot of fun, finger painting allows you to connect with the painting in a very literal way. It can also make for some interesting and unusual marks that are very quick and simple to apply.

### Late Summer - Over the Bay
'Gorse pops, a jackdaw calls...'

*The paint for the sky here was applied directly with my fingers. Moving around the paint on the surface is very enjoyable and allows you to produce great natural blending.*

*Dip the tips (or more!) of your fingers into a well of colour. You can use diluted or undiluted paint as necessary for your painting. Tap and smear the paint over the surface for a variety of different textural effects.*

## Stage 6:
# Tonal contrast

Use the corner of the size 12 flat brush to glaze St Michael's Mount with dilute phthalo blue, creating a rich dark silhouette effect. Using bigger strokes and more of the brush, build up the other foreground darks.

Change to a size 2 round brush and use a mix of titanium white and brilliant blue to paint in the distant headland along the horizon.

On the left-hand side of the painting, blend away the hard line of the horizon with dilute white. Use the corner of the brush to develop the sky, adding hints of a cadmium yellow and cadmium red mix for interest.

Add highlights to the sea using the size 2 round brush and titanium white. Follow the plane of the sea by using horizontal strokes, and apply these touches intuitively rather than to a plan.

Using a size 4 flat brush, apply relatively thick titanium white into the sea around the foreground rocks, helping to define them using negative painting. As you work towards the background, dilute the paint a little and use smaller strokes to create the sense of recession and scale.

Create depth in the sky using a mix of Winsor violet and titanium white, and a second mix of brilliant blue and titanium white. Use the heel of your hand to smooth in areas, working the paint away from the focal point.

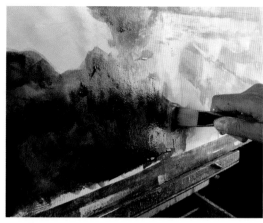

*The dilute blue glaze neutralises the warm burnt sienna, creating a neutral but interesting dark colour.*

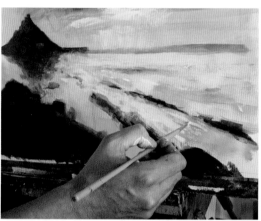

*The addition of the faint headland and detail on the sea further develops the painting's structure.*

*Don't be afraid to get hands-on to smooth the sky!*

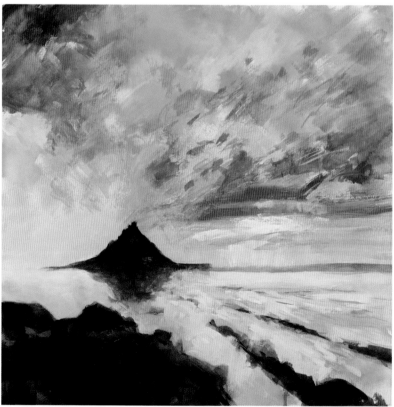

### The painting at the end of stage 6
*Deeper shades on the land and lighter tints in the sky create greater contrast in tones.*

## Stage 7:
# Finishing touches

Spatter a dilute mix of titanium white and brilliant blue over the reflection of St Michael's Mount. Use the same mix to add detail and interest across the sky and sea areas, applying the paint with the size 4 flat.

Scoop some heavy structure gel onto a spare piece of cardboard using a painting knife. Mix the gel with burnt sienna and phthalo blue, then apply the mix over the foreground rocks with the palette knife, creating texture with the flat, edge and point of the painting knife. Do not completely cover the rocks – leave a few gaps for interest. The finished painting can be seen on pages 68–69.

*Spattering is a quick way to create the suggestion of fine detail.*

*Using the same colour in the sea and sky creates realism.*

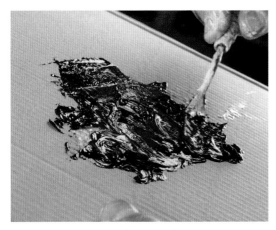

*Burnt sienna and phthalo blue make a strong, rich dark.*

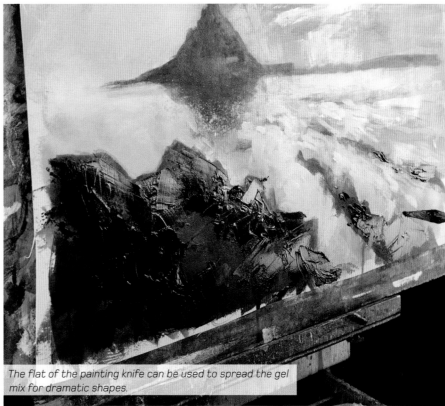

*The flat of the painting knife can be used to spread the gel mix for dramatic shapes.*

# What next?

We all know just how much the sky can vary, from season to season and from country to country. Our fiery sunset tutorial used strong colour and strong mark-making techniques, while a billowy cloud-filled sky (as below) will use softer techniques for a more fluid finish.

The sky and its light-altering capabilities govern almost everything that goes on in our landscapes and seascapes, creating not only sunlight and shadow but, crucially, atmosphere. As a result, the bright, vivid blue of a summer sky in Provence will lend a completely different atmosphere from a landscape of hills and towns from that of the drizzly grey sky of an English winter. In painting, both can be equally beguiling, with the hot crisp blue of summer lending an air of optimism, of well-being, of fast-forward fun; while the soft, enveloping, grey dampness of a long winter wraps us in melancholy, mystery and a sense of time standing still.

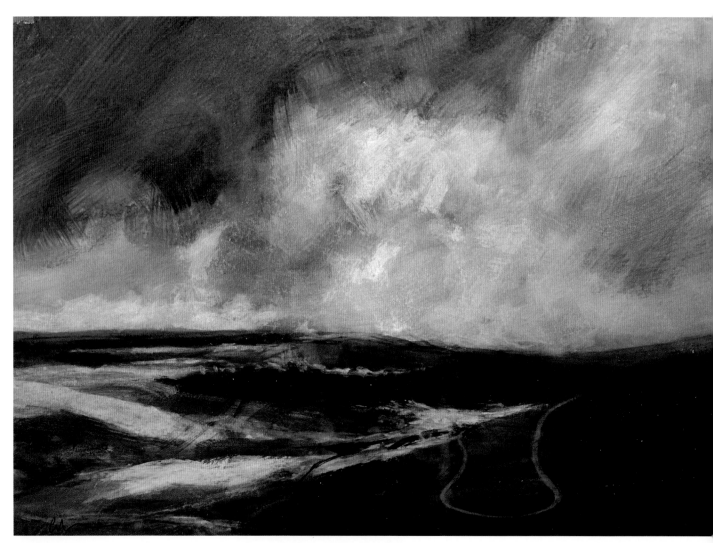

## Rhondda Skies

*The sky in this painting of the Rhondda Valley, Wales, is created with paint applied with a sponge and fingers. Soft in approach, gentle in detail, this painting uses layered muted tones to give depth to the sky and clouds. In contrast to the warm energy of our tutorial sunset, this sky says 'grab your coat, there's rain on the way...'*

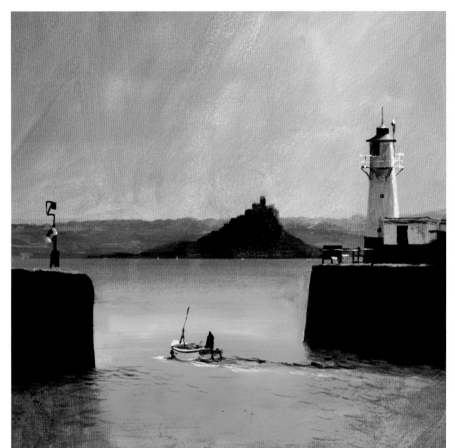

## Through the Gaps

*The sky and light source in this painting has been kept reasonably simple in approach, to help keep the focus on the lighthouse and boat. Keeping the sky pale throws the lighthouse (which is in fact pure white) and the silhouetted distant landscape forward.*

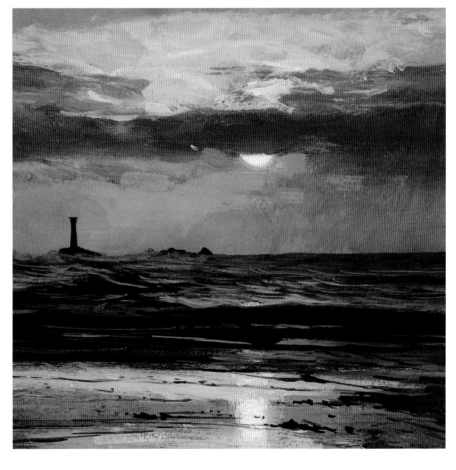

## Longships

*Heavy, luxurious brushwork was used to spread the buttery rich paint onto the board in swathes. All the time I was applying paint, I was trying to mimic the heavy sky bearing down onto the fragile lighthouse.*

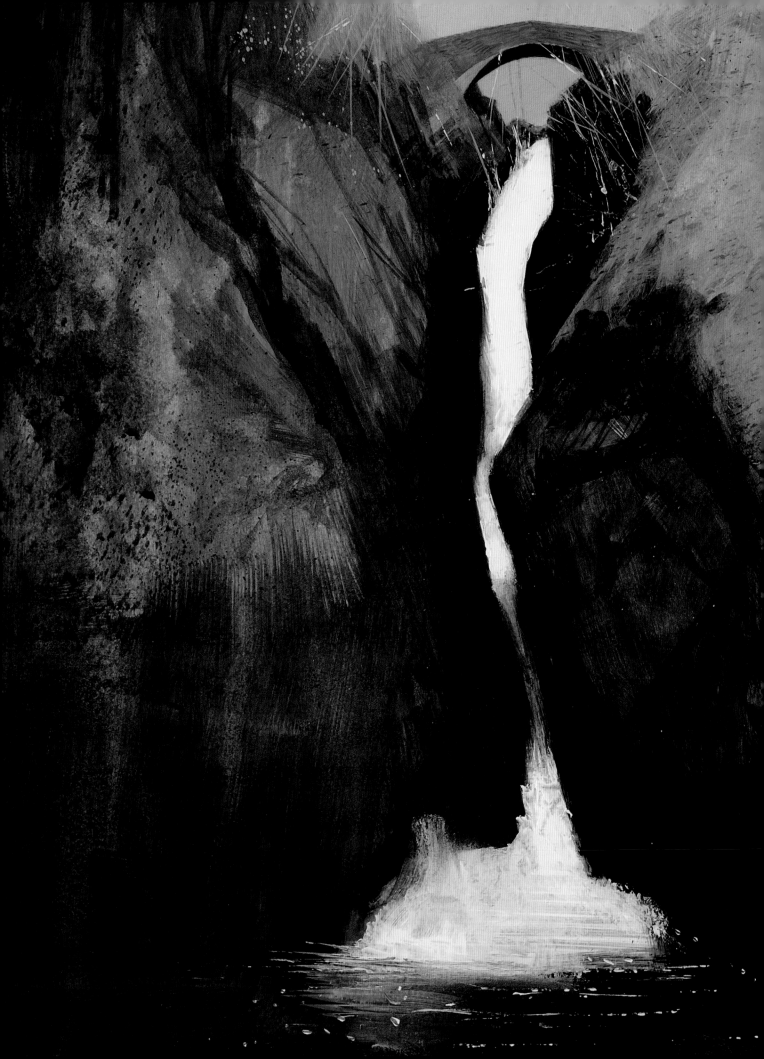

# WOODLAND & WILDERNESS

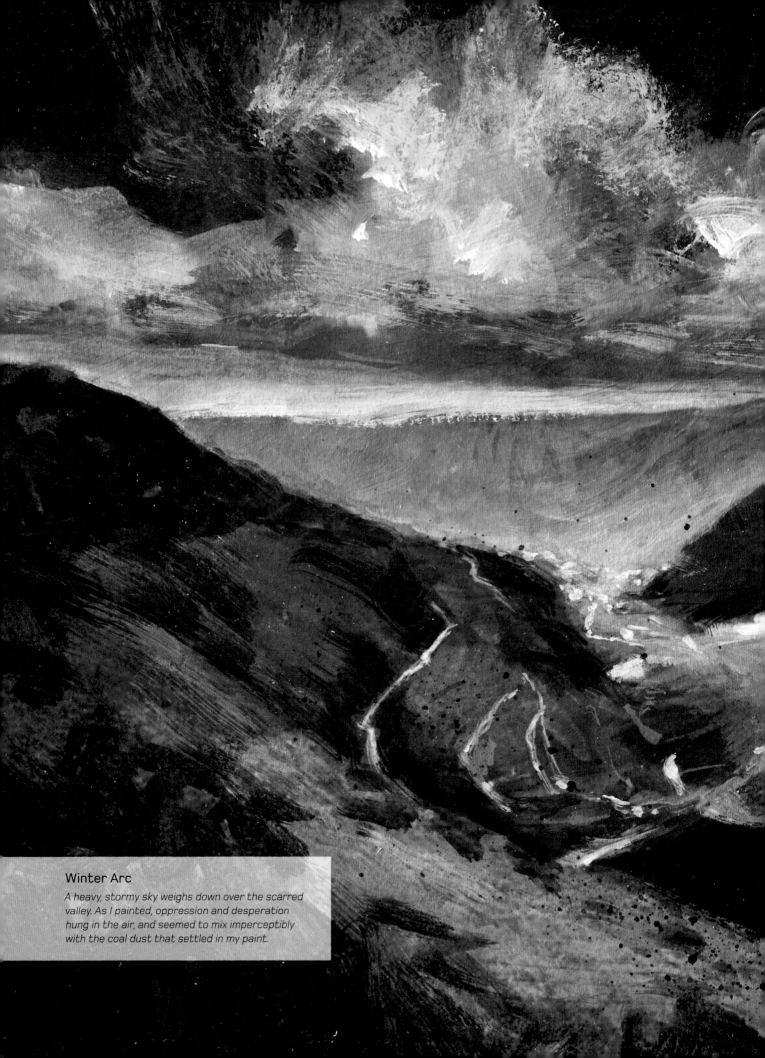

## Winter Arc

*A heavy, stormy sky weighs down over the scarred valley. As I painted, oppression and desperation hung in the air, and seemed to mix imperceptibly with the coal dust that settled in my paint.*

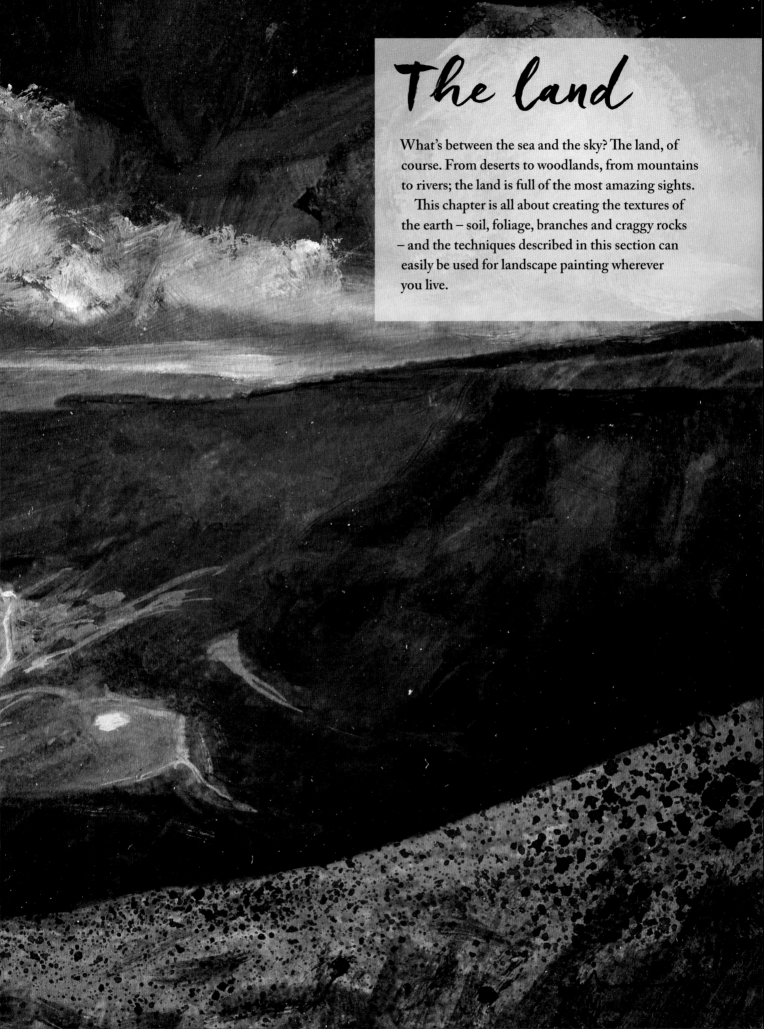

# The land

What's between the sea and the sky? The land, of course. From deserts to woodlands, from mountains to rivers; the land is full of the most amazing sights. This chapter is all about creating the textures of the earth – soil, foliage, branches and craggy rocks – and the techniques described in this section can easily be used for landscape painting wherever you live.

# Opportunities and challenges

There are challenges when painting the great outdoors. How do you capture the heat and sheer size of a desert canyon? And how best to envelop the viewer in a verdant, wild woodland? These are challenges that we will look at in detail.

## Flagstaff

*It was 21°C (70°F) where I stood looking up, and yet the mountain top was still covered in snow – it seemed incredible. Here, the swirling wintery sky is allowed to blend with the top right of the mountain landscape, while cool blues on the peak contrast with the verdant summer landscape below.*

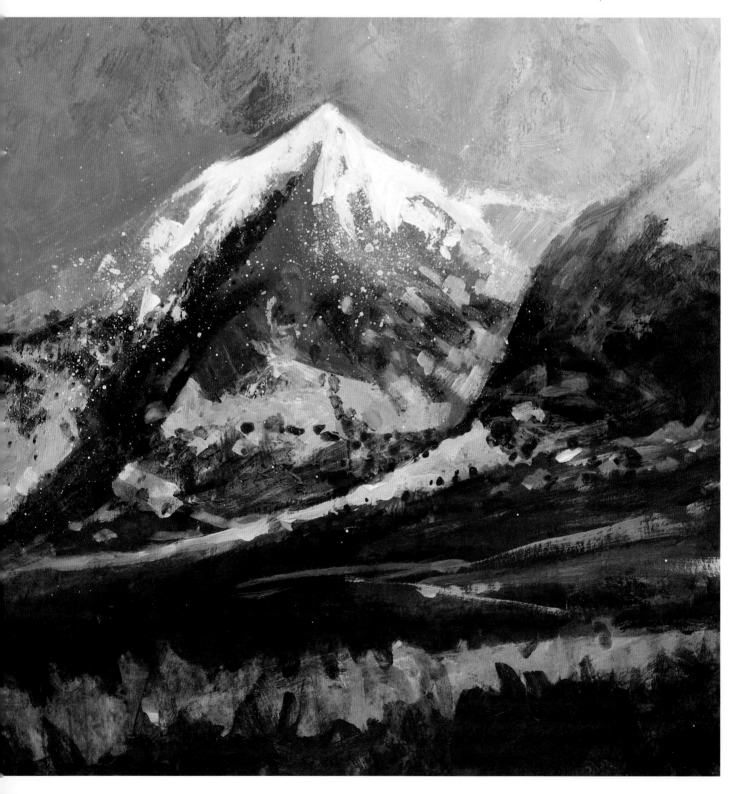

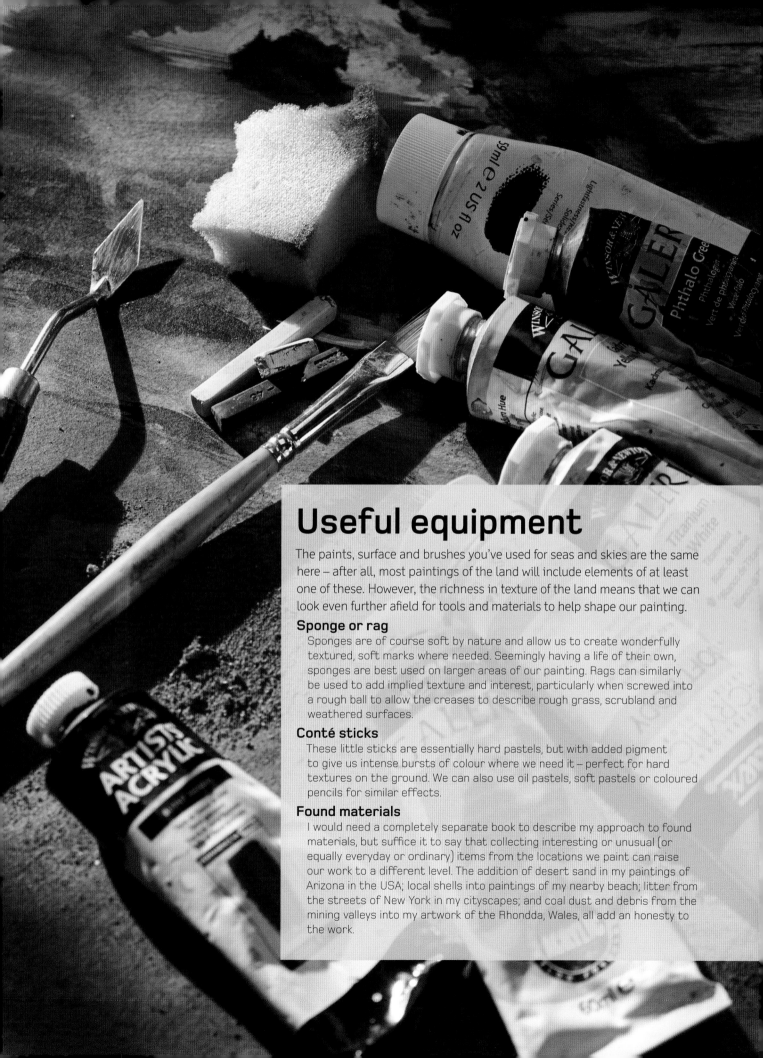

# Useful equipment

The paints, surface and brushes you've used for seas and skies are the same here – after all, most paintings of the land will include elements of at least one of these. However, the richness in texture of the land means that we can look even further afield for tools and materials to help shape our painting.

## Sponge or rag

Sponges are of course soft by nature and allow us to create wonderfully textured, soft marks where needed. Seemingly having a life of their own, sponges are best used on larger areas of our painting. Rags can similarly be used to add implied texture and interest, particularly when screwed into a rough ball to allow the creases to describe rough grass, scrubland and weathered surfaces.

## Conté sticks

These little sticks are essentially hard pastels, but with added pigment to give us intense bursts of colour where we need it – perfect for hard textures on the ground. We can also use oil pastels, soft pastels or coloured pencils for similar effects.

## Found materials

I would need a completely separate book to describe my approach to found materials, but suffice it to say that collecting interesting or unusual (or equally everyday or ordinary) items from the locations we paint can raise our work to a different level. The addition of desert sand in my paintings of Arizona in the USA; local shells into paintings of my nearby beach; litter from the streets of New York in my cityscapes; and coal dust and debris from the mining valleys into my artwork of the Rhondda, Wales, all add an honesty to the work.

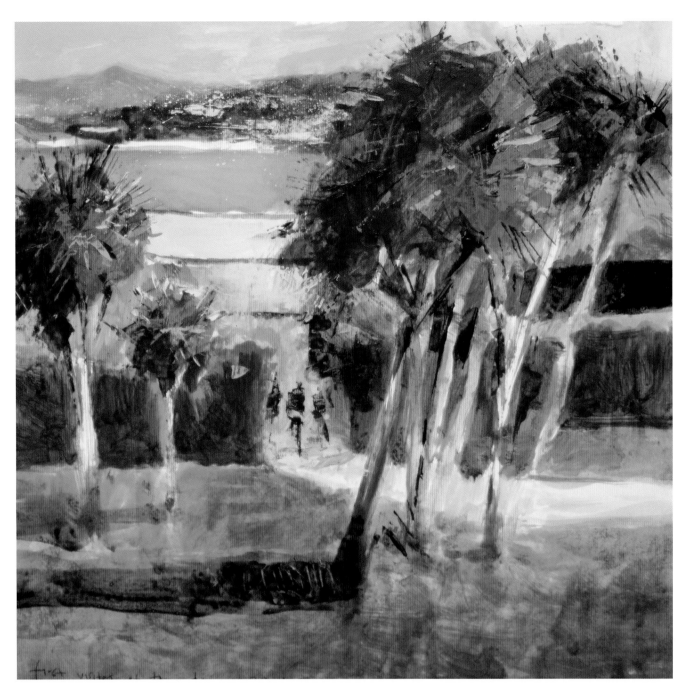

# Texture

You may not always have your glues, mediums and gels with which to apply found materials to your paintings, but you can still create implied texture – this is where acrylics really come into their own. Paint can be applied in various ways to suggest different textures: wet into wet work, flat milky washes and opaque impasto will all give different impressions. Contrasting soft brushwork and sponged softer areas with heavier, rugged impasto and scratching through heightens this effect.

You can of course add impasto work using a palette knife but often it's more fun and interesting to find other materials to produce similar marks and effects. How about a found stick, or a sharp stone or dry seaweed?

### Cornish Palms

*The very soft wet-into-wet areas of this painting are contrasted with spiky impasto palm leaves.*

*Working very quickly en plein air necessitates using a limited palette of colours and a limited box of mark-making equipment – and so I used the hard, spiky end of a fallen palm leaf to add the impasto leaf shapes to the painted palms and to scratch through into the painted shadows.*

# Foliage and soil

The following pages examine how we can create texture in our paintings. Because they are full of lots of different textures, I have chosen to focus on woodlands in particular, but these same practical techniques will work for many subjects and approaches.

Woodlands, trees, plants and the soil that they grow from are of course organic, and it is this organic quality that I try to convey in my paintings of the subject. The best way that I have found to produce these effects is to use the organic materials themselves. Why not collage with the leaves, or stamp paint with the skeletal structures? I'm sure you remember doing exactly that from your school days. Experiment with mixing the soil and earth with your paint. Does that add texture and interest?

Organic subjects can appear complex, and they are always fluid – fluid in form and fluid in movement. As the eminent architect and polymath William Kent (1685–1748) stated in 1730, 'Nature abhors a straight line'. Let's have a look at just a few of the many ways that we can describe nature and woodland, and see if we can avoid those straight lines...

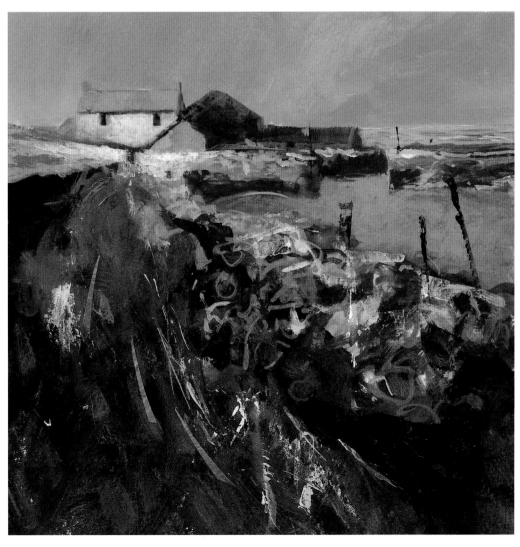

### High on the Moor
*The idea behind this painting was to render the old farm buildings as though they had grown out of the ancient landscape by themselves, organically, with little – if any – help from man. Natural, local colours were key. I used a combination of soft, woolly sponged marks together with slightly more controlled brushwork to achieve this. A few small additional elements of collage were used to create crisp lines to draw the eye into the contrasting curves.*

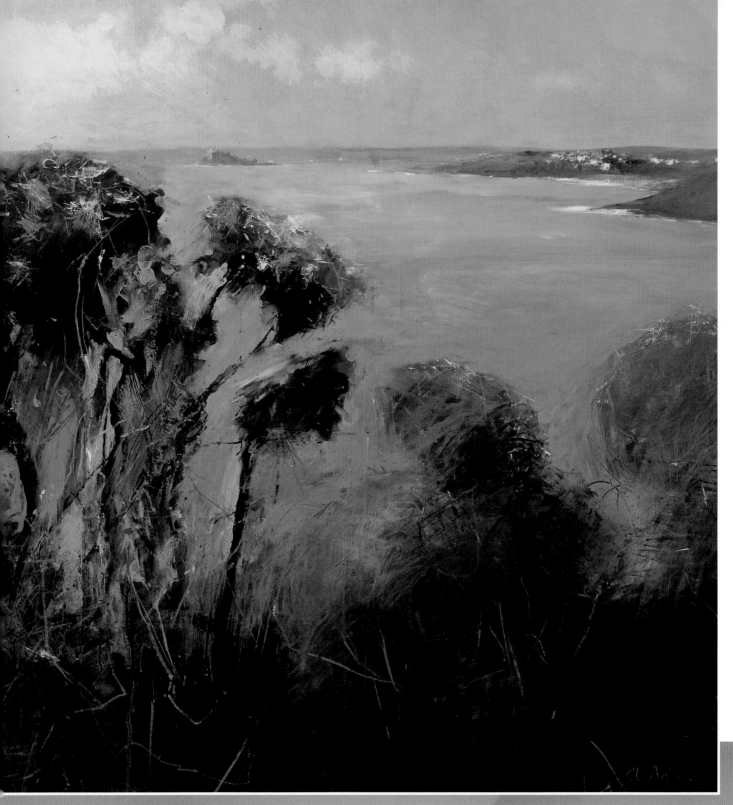

## Variety of texture

Strong contrast in tone or hue makes for striking pictures. The same is true of textures. Including a variety of textures and marks in your paintings – from smooth, flowing brushstrokes to frantic scribbles with a conté stick – will create interest in your artwork.

### Gorse

*Being spiky in nature, gorse needs spiky mark-making to help describe its feel. Short, stabby, angled lines seem to fit the bill here. These marks are best applied with a fairly sharp instrument such as a crisp conté stick. Alternatively, you might use paint on a palette knife or a cut-out piece of an expired bank card. Perhaps the best way of describing the texture is to apply the paint with a piece of the gorse itself.*

## Conté

Conté sticks are great for highlights as they allow lovely effects that pick up the texture of the paper.

Use them exactly as you would a pastel or pencil to add details to your paintings.

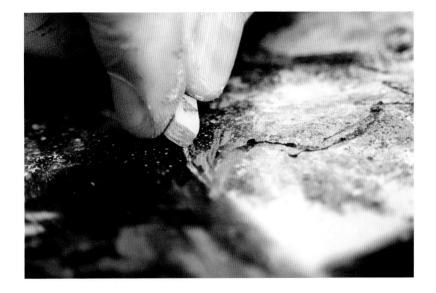

## Sponging

A quick and effective way to suggest detail is by using a sponge. Acrylic is opaque enough that overlaying light colours will 'read out' of darker underlying layers.

To use the sponging technique, tear off a piece of household sponge and dip it lightly in some slightly watered-down paint. Dab away excess paint on a rag or piece of kitchen paper, then dab the surface of the painting lightly.

### Cornish Palms

*Sharing similarities with Gorse through the dense bursts of foliage at the end of long stems (well, tree trunks here) and having the sea in the background, this painting has a brighter, fresher feeling. Because the palms are more distant from the viewer than the gorse is in the painting on the opposite page, I have kept the textures lighter and smoother. That's not to say there's no texture, but here it is made with brushmarks rather than the very fine conté sticks.*

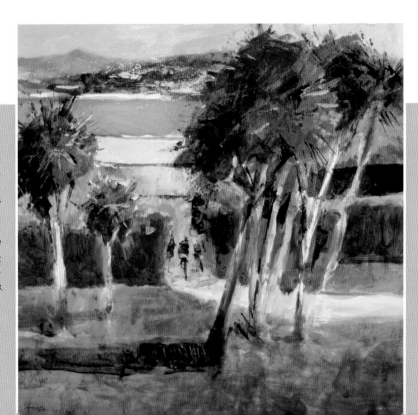

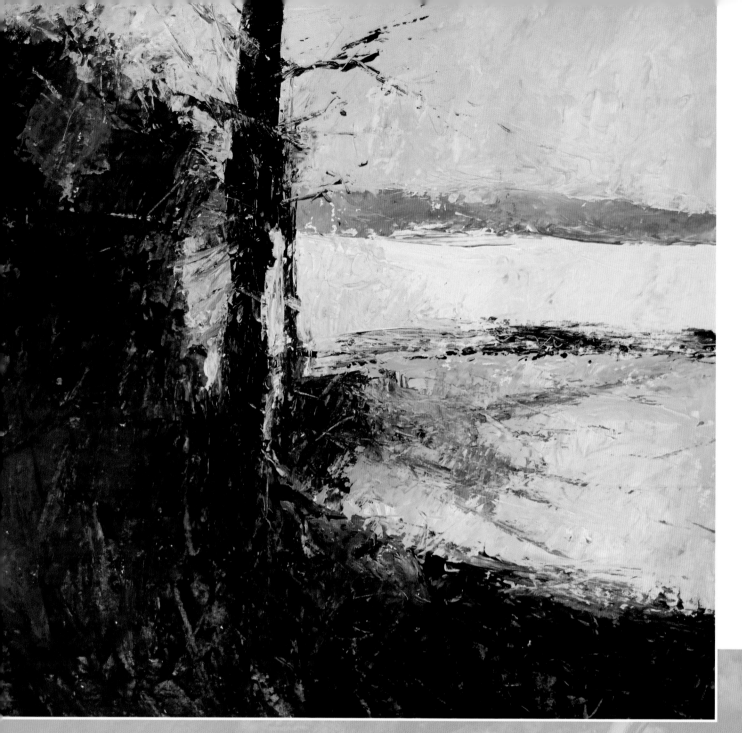

## Lose your brush

You don't need a brush to paint – anything that allows you to get the paint on the surface will work – whether it's a stick, a stone, your fingers or a rag. Each will create great useful effects, and one of my favourites is a painting or palette knife.

Painting using a palette knife enables you to create rich texture and saturated colour. The use of undiluted heavy-bodied acrylic paint can also help to combat wintry and windy conditions as there is less chance of the paint being splattered over your work by a cheeky breeze!

### Lone Pine

*Painting outside on location often means battling the elements, and one of the hardest weather conditions to argue with is a strong sou'westerly! At times such as these I concentrate more on impasto mark-making – that is to say, using my acrylic paints straight from the tube, and mixing them on the painting surface itself. Not only does this approach prevent the wind blowing the paint around (a risk with wetter, more dilute paint) but I am also able to use the buttery acrylic to create instant texture, ideal for grass, tree trunks, branches and leaves. The paint itself is applied with a wide variety of traditional painting implements and found materials.*

# Using a painting knife

Shaped a little like a tiny trowel, a painting knife is a blunt metal blade on an angled handle. They come in various shapes, but as long as they have an edge and a flat surface, you can produce great 'choppy' results with thick acrylic paint.

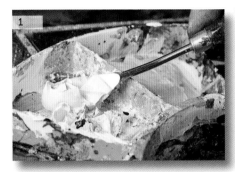

**1** Load the painting knife with paint by dipping it in a well of colour and lifting out a decent amount of paint.

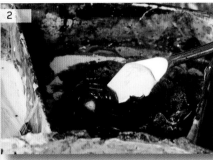

**2** Without cleaning it, dip it into a second colour well to pick up some of that colour on the end.

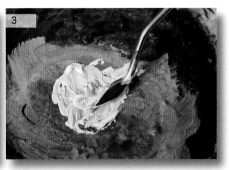

**3** Chop and churn the colours together to mix them on your palette.

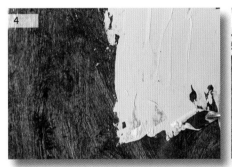

**4** Apply the paint to the surface fairly thickly, using the back of the knife. Think of the action as like spreading butter.

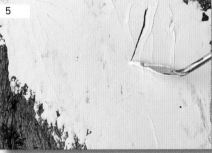

**5** Once the paint is applied, you can use the point of the knife to scratch out fine lines from the wet paint, revealing the underlying paint beneath.

**6** Angle the knife and use the edge to scrape paint away from larger areas. This gives a lovely broken effect.

## High on the Moor

*Similar mark-making techniques to those used in Lone Pine (see opposite) were used in this moorland painting. Paint was built up with the impasto technique to create the foreground texture but here the rugged area is balanced against wetter, flatter areas of paint used in the field and sky.*

*Mixing textures can be a very effective way to create interest and the illusion of space in a painting. I often like to experiment with varying levels of texture simply to find new, exciting ways of portraying a creative image.*

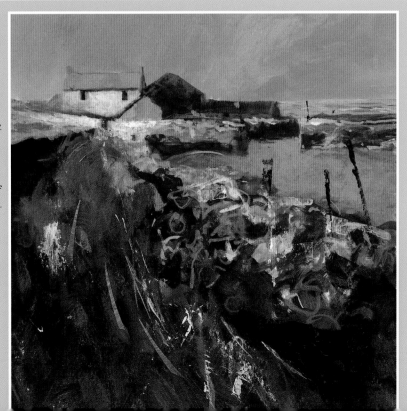

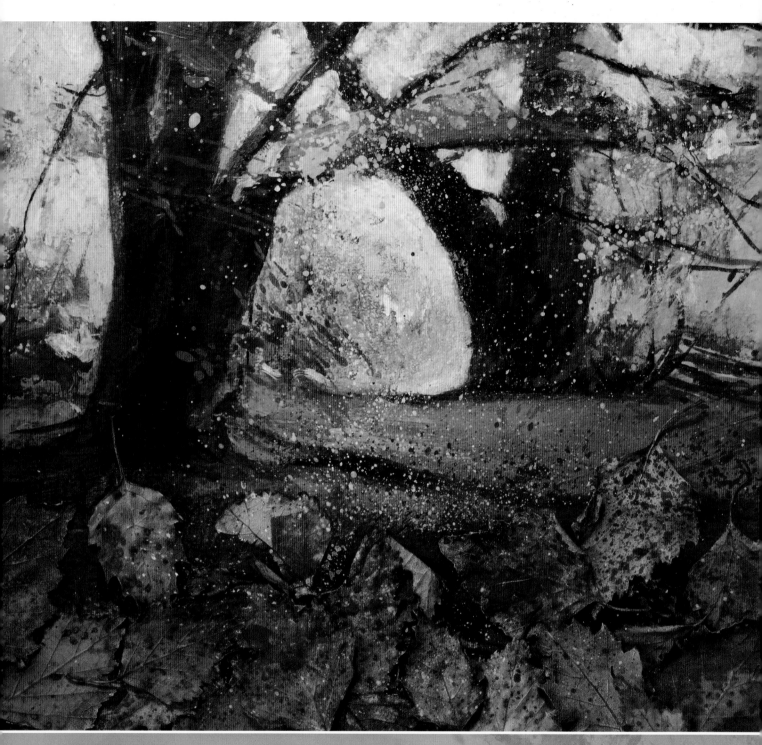

## Incorporating found materials

For me, incorporating found materials helps to ground a painting to its unique location, be it a Texan canyon or a city street; a bustling harbourside or a remote mountain top. Using found materials is a great way to add authenticity and conviction to your art and works really well with paper ephemera, sand, shells, earth, leaves – in fact, almost anything that can be fixed to your painting surface.

### Autumn Leaves

*I love to use found materials; nothing captures the feel of a location more than elements found on the spot. In this case, fallen silver birch leaves were used as collage in this woodland scene. The woods were a curious mixture of birch and oak, and the smaller birch leaves made the better collage material in this instance.*

## Attaching found materials

Collage pieces, like paper cut from magazines, can be attached using a simple glue stick, while watered-down white glue, like PVA, can be used to attach loose materials like leaves or seeds. Some found materials, however, require something a little more 'heavy duty' to ensure they stay attached. You can use superglue to secure things like larger twigs individually.

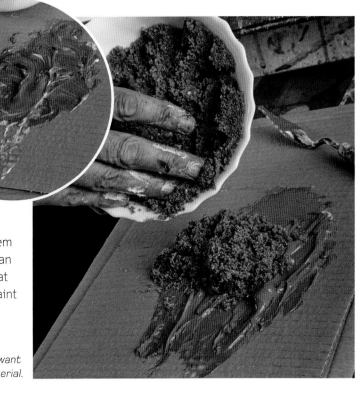

   You can also mix materials like sand or fine gravel with an acrylic medium such as texture gel and apply them to the surface as a mix. The advantage here is that you can combine the gel and sand mix with paint, giving you great freedom with colour and texture. Heavy-bodied acrylic paint will generally form a strong enough bond to hold loose material like sand in place on its own.

*Mix the texture gel with the colour you want (see inset), then add the scatter material.*

## Spattering

A fun and very quick way to add action and movement, spattering creates unpredictable results that can enliven your painting.

   There are many variations on this technique – you can use a paintbrush, an old toothbrush or even just your fingers.

**1** Load a brush with diluted paint and hold it near the end of the handle. Put your other hand a short distance from the painting surface.

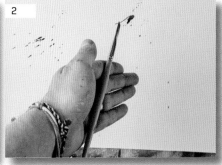

**2** Sharply strike the paintbrush against your hand to spatter the paint over the surface.

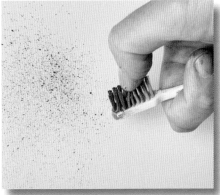

*To use a toothbrush, dip the bristles in dilute paint, hold it near the surface and draw your thumb along the bristles. This will produce a fine spattering spray.*

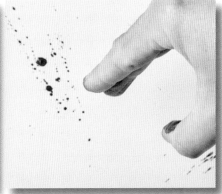

*Dipping your fingers in paint and flicking them tends to produce larger blobs of paint than the other approaches – and is great fun!*

# Sunlight and Shadows

This demonstration uses a combination of wet-into-wet techniques together with opaque negative painting and conté work. Breaking down complex areas into simple shapes helps to stop the scene from becoming too fussy. The river itself draws the viewer's eye back and forth, in and out of the painting.

The key elements to a relatively quick study such as this are to keep the mark-making rapid, loose and vigorous. Go with the flow. If wet paint flicks, drips and dribbles where it shouldn't, incorporate those cheeky accidents into the work. Paint the darks simply, using glazes; for glazed darks add mystery. Temper the darks with highlights and sunlight; negative painting works well here.

Close your eyes, imagine the scene. Smell the foliage, hear the river water roll over the polished stone – and paint with confident abandon.

**The finished painting**

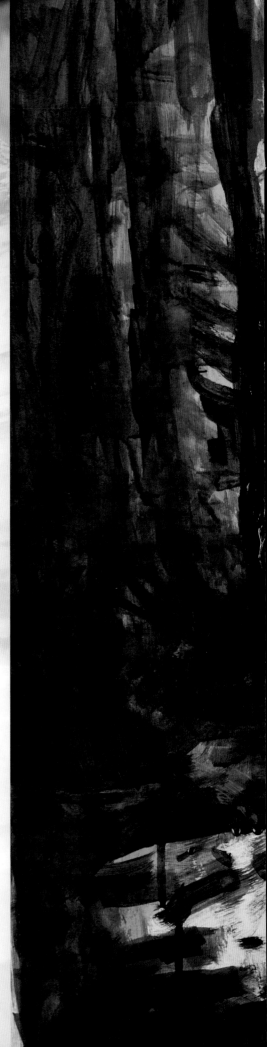

## Stage 1:
## Capturing the scene

My sketchbooks are full of woodland scenes. Trees are one of those subjects that simply scream out to be drawn. For me the pencil and pen really come into their own when describing the twisting of trunks and branches, jumble of leaves and the filtered, patterned sunlight and shadow. My tat bag is also crucial when working in the woodland environment: a handful of fallen leaves, collected and brought to my studio, are able to give me vivid recollections by fragrance alone.

For me, the river gliding endlessly through the sunlit wood was the main attraction of this piece. The brightness and lightness of the river was made all the more apparent by the tall, dark trees and mysterious shadowy areas. The bright sunlight was another key element, helping to bring sparkle to the river water and colour to the foliage. These contrasts in tone, shade, shape and movement are often the building blocks for our paintings, and if we can get these elements right, we set ourselves up for success.

## What you need

60 x 60cm (23½ x 23½in)
square of mountboard

Brushes: size 12 flat, size 4 flat

Paints: cadmium yellow, titanium white, French ultramarine, phthalo green, burnt sienna, Winsor blue (red shade)

Sponge

Painting knife

Conté sticks: light yellow, cream and blue

Pencil, eraser and ruler

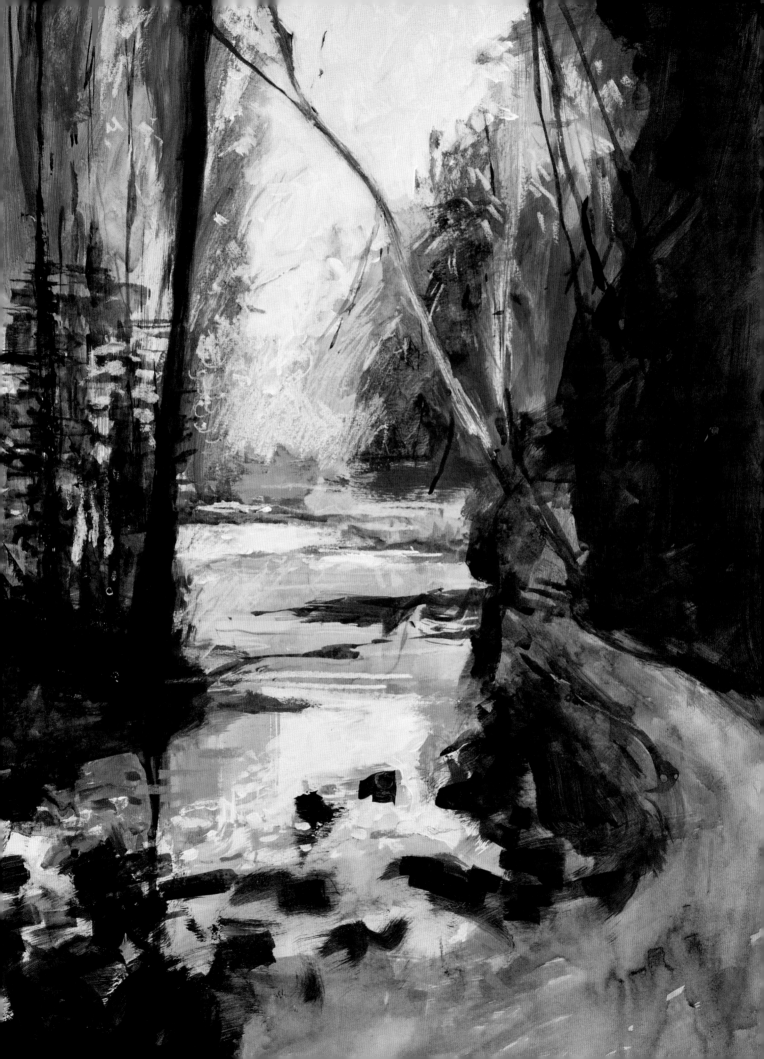

## Stage 2:
# Laying out the colours

Add a grid and sketch out the main objects using a pencil, then use an eraser to remove the grid. Use a sponge to apply dilute cadmium yellow over the central area, leaving a few gaps of clean board. Add some titanium white to the yellow and use light scrubbing motions to blend in lighter tones over the very central area.

Without cleaning the sponge, add a little French ultramarine to the mix and apply over the river. Let the colours blend on the surface.

Add phthalo green to the same mix and build up the colour on the left-hand side. Use vertical strokes for the trees and change to horizontal strokes for the ground and river bank.

Continue to build up the green with the sponge and the same colours. Add more paint as necessary for variety in consistency.

*Leaving the grid lines outside the border can be useful reference after you have started painting.*

*A sponge allows you to apply paint quickly and freely.*

*A handheld palette will speed up your working.*

### The painting at the end of stage 2
*Spongework gives a loose effect and great coverage quickly – perfect for the underlayer.*

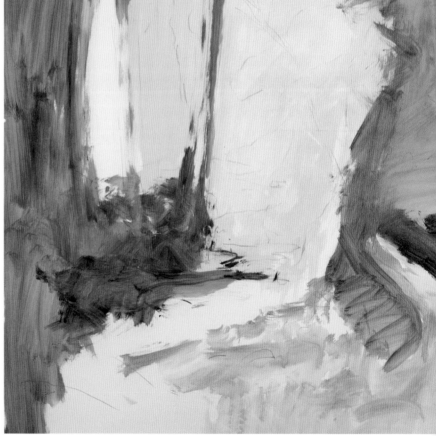

# Stage 3:
# Drawing out the details

Make a dark mix of burnt sienna with French ultramarine and use small dabbing motions of the sponge to add dark recesses and wet rocks in the river.

Build up darks across the painting, using the edge of the sponge for finer trees. Add water, more French ultramarine and some cadmium yellow to the mix to create a dilute blue-green. Use this to add dabbed marks over the foliage area.

Using the edge of a size 12 flat brush, add some texture on the horizon line of the river with a mix of titanium white and French ultramarine.

Extend the texture up into the foliage at the edges of the painting surface using the same mix and the flat of the brush to add square brushstrokes.

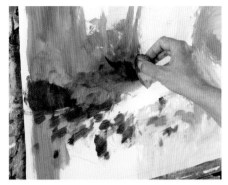

*Start with the river and move on to the surrounding areas.*

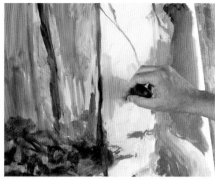

*Dabbing creates a textured glaze that suggests light coming through the distant trees.*

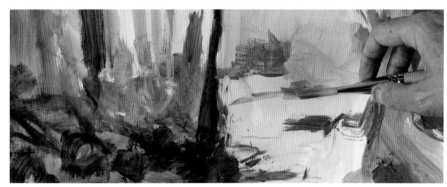

*Adding the horizon line.*

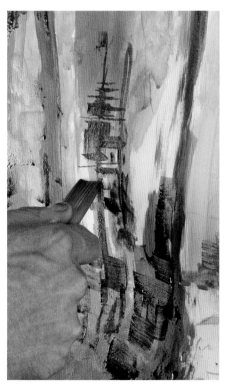

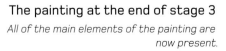

*Hold the brush near the bristles for control.*

## The painting at the end of stage 3
*All of the main elements of the painting are now present.*

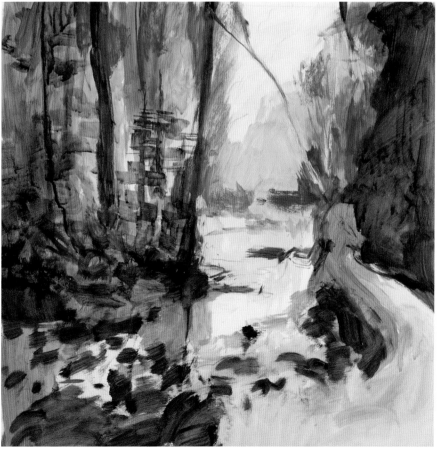

## Stage 4:
# Refining

Extend the texture up into the foliage at the edges using the same mix and the face of the size 12 flat brush to add square brushstrokes. Use the blade of the brush for very fine lines, and when the brush starts to run out of paint, scrub the face of it lightly over the tree structures to suggest light leaf cover.

Change to a size 4 flat and apply pure titanium white to the river below the remaining yellow area. Use choppy touches of both the face and corner of the brush to add

movement and texture. Build up the sky with smoother touches of pure titanium white, still using the size 4 flat brush, then add burnt sienna to the rocks at the front. Vary the hue with cadmium yellow. Hold the brush further back than you might usually. This reduces your control and helps to create exciting, dynamic touches.

*The versatile flat brush gives a wide variety of marks and tones for refining foliage – all from one brush load of paint.*

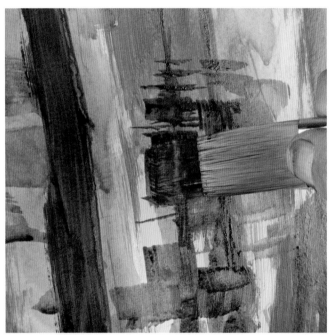
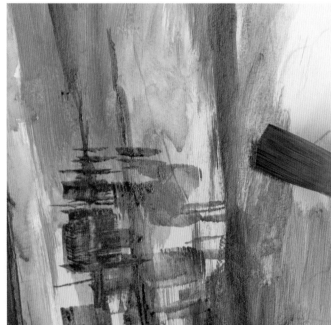
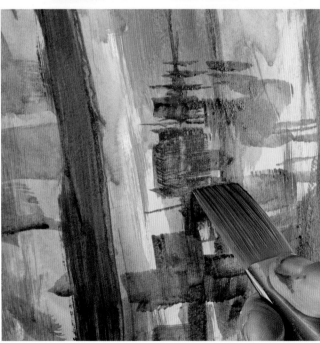
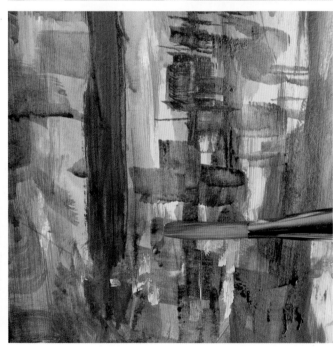

*Add fine details with the corner of the small (size 4) flat brush.*

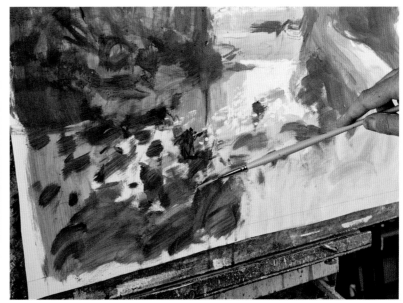

*Burnt sienna touches add light and warmth to the foreground texture.*

**The painting at the end of stage 4**

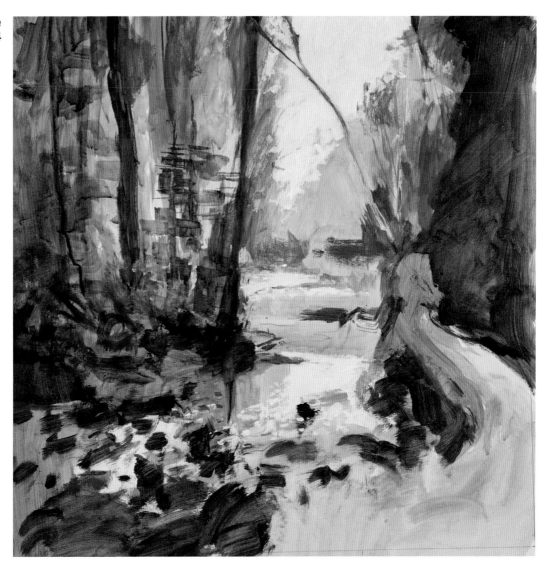

## Stage 5:
# Finishing

Use the size 4 flat and a dark mix of burnt sienna and Winsor blue (red shade) to build up the dark areas, concentrating on the rocks and trees. Use the side of the brush to draw fine lines to suggest trees and branches.

Dilute the dark mix and use it to glaze the lower right-hand corner with scrubby strokes. Follow the shape of the land so the eye is led around the painting. Aim to create depth across the painting with darker mixes in the foreground and less contrasting tones in the background and midground.

Strengthen the green in the background with drybrushed strokes of a dilute mix of phthalo green and cadmium yellow.

Using negative painting (see page 63) and the size 4 flat, add touches of a blue mix of Winsor blue (red shade) and titanium white to the background and midground to suggest the trunks of trees, and the same mix for the background part of the river.

Use combinations of phthalo green, French ultramarine and burnt sienna to add fine dark marks in the foreground trees with the painting knife. Change to the flat of the knife for thicker marks on the trunks of the trees, and soften the effects towards the edge of the painting by using your fingers to add texture to the trunks.

With all the darks in place, use light yellow and cream conté sticks to add hard calligraphic marks as highlights and sunlight through the foliage. Use the side of the sticks for thicker marks, and the corners for finer touches. Use a blue conté stick for the river in a similar way. Follow the contours and planes of what you're drawing – adding lines that follow the lines of the trunks in the midground, for example.

Once you are happy with the conté stick additions, the picture is complete. The finished painting can be seen on pages 94–95.

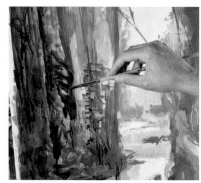
*Strengthening the midground and foreground draws the eye forward.*

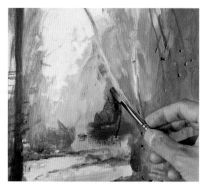
*Dark greens applied around foreground shapes push those branches forward.*

*The painting knife is versatile and can produce a variety of textures.*

*Fingers can soften hard marks.*

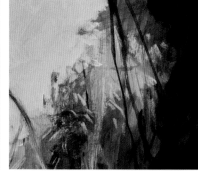

*Use a variety of marks to create the correct textures for each area when using the conté sticks.*

# What else could you do?

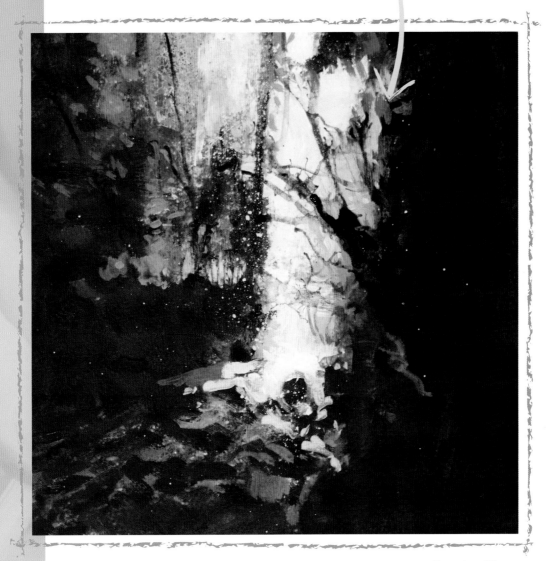

Running River

## Blown paint

This technique will almost certainly be familiar from your school days. It is a fantastic way to create branching marks with paint in a spontaneous but semi-controlled way.

Simply apply watery paint to the surface – either dripped or with a brush – then blow through a straw to direct the paint. You can control the flow by blowing more or less strongly.

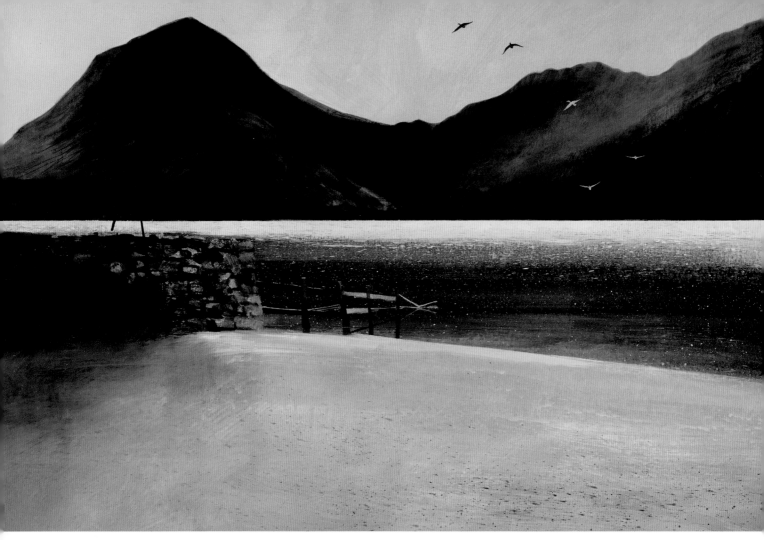

# Tone and impact

Tone creates impact. It is another key element that can make all the difference to our artwork. If 'tone' is new to you, just think of how a black and white photograph works; all those varying greys from virgin white to bible black. Each colour and shade that we use in our paintings has a 'tonal value'. That is to say, if we could see only in black and white, all the different colours of paint would appear as individual greys somewhere along the scale.

Until the Impressionists showed up and started slapping colour onto pure white canvasses with abandon, artists always worked by building a tonal painting first, often in shades of brown, from pale to dark. The colour itself was added only towards the end of the painting process. I tend to take my cue from the Impressionists, and enjoy using colour in its purest form. However, I always bear in mind how tone influences the success of a painting and this important consideration is crucial in the ongoing decision-making process of creating paintings. Using acrylics makes this process easier for us as we can of course bounce back and forth, working lights over darks and vice versa.

Look for the darkest greys or blacks, and search for the palest whites. These extreme darks and lights become the cornerstones for our tonal painting. If we get these right, we are set up for success. It pays to bear in mind that darks are always darker the closer they are to you, so if we keep the strongest darks in the foreground, we can create that elusive sense of space and drama.

## Buttermere – The Lakes

*The steep fells and calm lake are modelled with little more than simple darks and bright whites. Any colour used plays a minor supporting role in comparison.*

*This is a deliberate attempt to show how extreme tone works – squint at this painting to reduce it to an image of tones, a little like a black and white photograph.*

## Tip

If you are working from a digital photograph, try converting the colour image to a greyscale or black and white setting on your camera or computer. You will then have an accurate tonal version of your image.

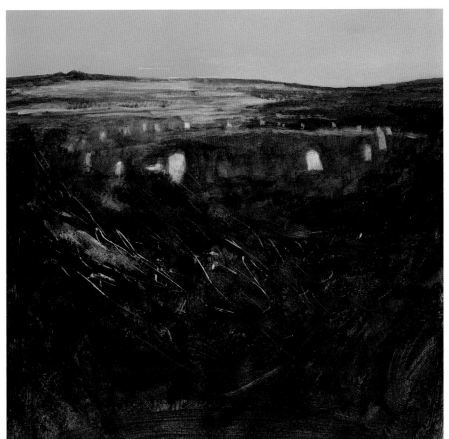

## Kenidjack, Cornwall

*The colours used in this painting – raw sienna, burnt ochre and olive green – are used purely to describe the season. With its strong tones – deep darks and pale accents – this could work equally well as a black and white charcoal drawing.*

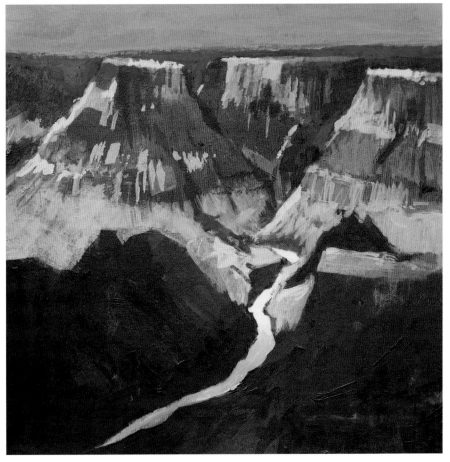

## Grand Canyon #1

*The tonal impact of this painting is used to create space. The dark-toned shadows in the foreground give the brightly lit canyon walls an extra sense of majesty as the Colorado River carves its way through the landscape.*

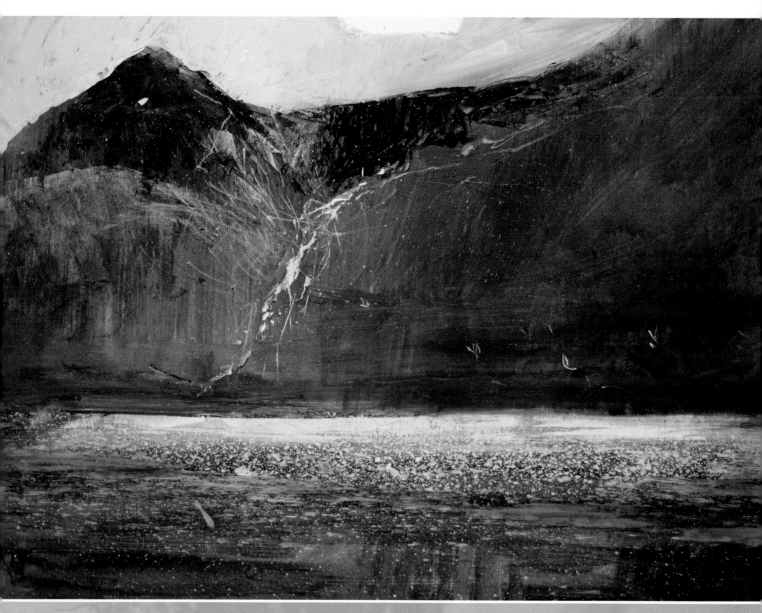

## Found materials as tools

I love to use found materials as collage elements or even as the painting surface itself, but it is equally valid to use found materials to apply or take away paint.

    The example above is a quick study of Buttermere in the Lake District, UK. Measuring 30 x 21cm (12 x 8in), it was painted at the lakeside using a piece of sponge, a toothbrush and a found stick. What else do you need?

### Buttermere Study

*This was painted with small, scratchy marks to emphasise the scale of the lakeside fells. The tiny bird shapes on the right side add to the sense of scale as well as suggesting motion across the painting, leading the viewer's eye from left to right. Compare this with Canyon (see pages 110–111) which uses larger mark-making techniques to bring the main elements of the river and foreground trees into the foreground.*

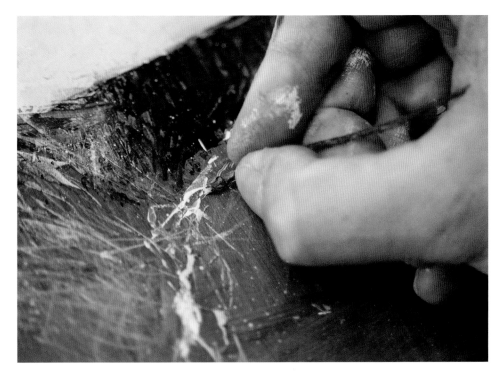

*This stick, picked up from the ground where I was working, was used both to apply paint for the waterfall and to scrape back colour to enhance the texture of the fellside.*

## Scratching out

As a technique, scratching out is almost self-explanatory. You simply use a pointed object to gently scratch at the painting to lift away some paint and reveal the surface underneath. You could use a palette knife or similar, but using a stick gives less control and therefore a more organic type of mark, one that almost makes itself.

Scratching out tends to work better while the paint it still wet, but you can work on dry paint if the surface will stand it.

### Buttermere – The Lakes

*This version of Buttermere is much larger than the study opposite, and uses a larger variety of techniques. These include sponge work on the lakeside fells, palette knife painting with collage on the old stone wall, toothbrush 'flickety-flick' on the lake surface and glazing to help create the misty atmosphere on the fells. Once again, tiny birds are added to give scale and to create movement. Note how the white birds sing out against the dark mountains, while the birds against the light sky are painted in a contrasting dark tone.*

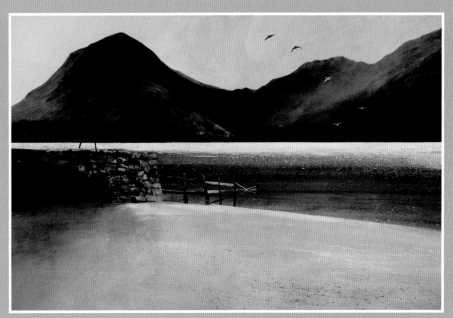

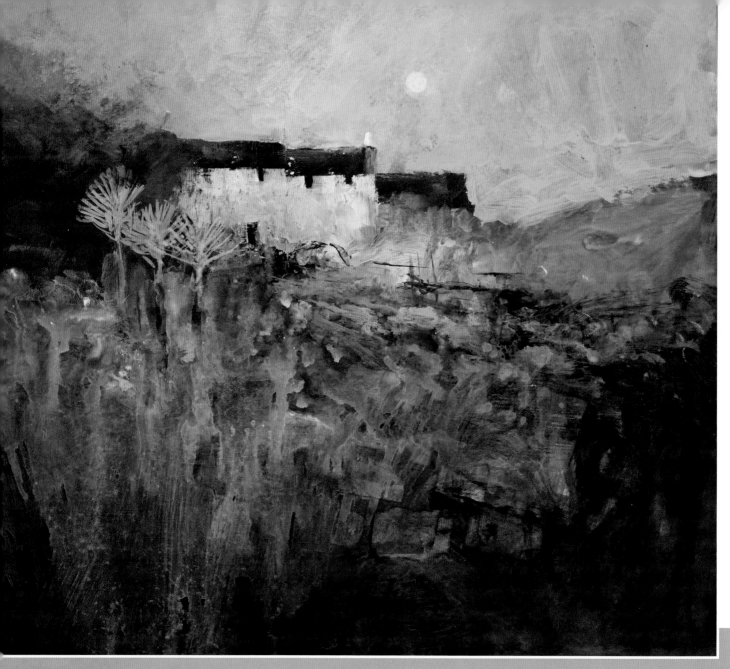

## Washing out

Washing out colour is basically a process of 'washing' elements of nearly dry paint off the surface to reveal the layer beneath. The effect leaves the painting with a ghostly softness that is fantastic for misty effects or to suggest distance in your artwork.

### Moorland Farm

*Built up using layers of paint, the orange breaking through in this painting is actually a burnt umber glaze over a cadmium yellow. The resulting colour works as a complementary hue to the blues and greys, both lending a much-needed warmth and richness to draw the eye. The washed-out whites and blues help to convey the wintry feel that I was looking for.*

## Washing out colours

Washing out creates texture and implied detail. It is a relatively loose and uncontrollable technique, and the surprising and unexpected results make the process all the more fun!

It is also simple – you just add more acrylic over a dry area. Before the new layer dries, a wet sponge is wiped gently over the surface. The water washes down the painting surface taking some of the new acrylic paint with it, simultaneously leaving an interesting texture.

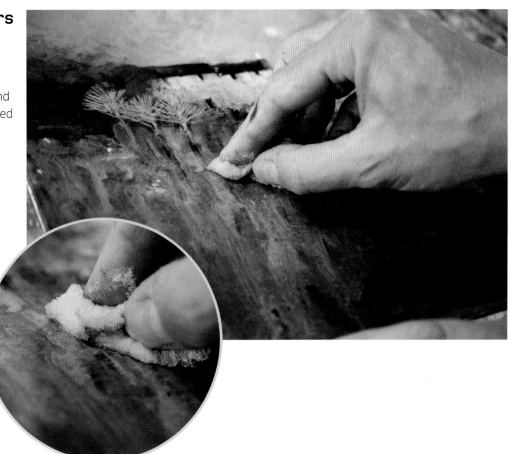

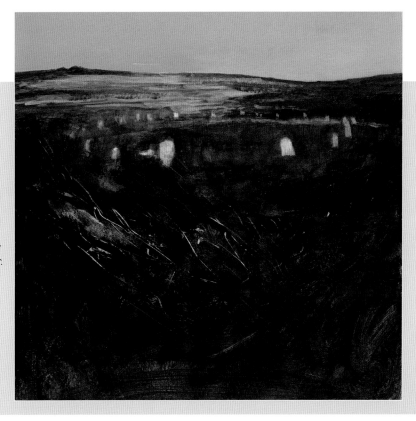

### Kenidjack, Cornwall
*Compare this scene with Moorland Farm opposite, where sharper detail and a clear sky suggests the windswept valley at another time of year.*

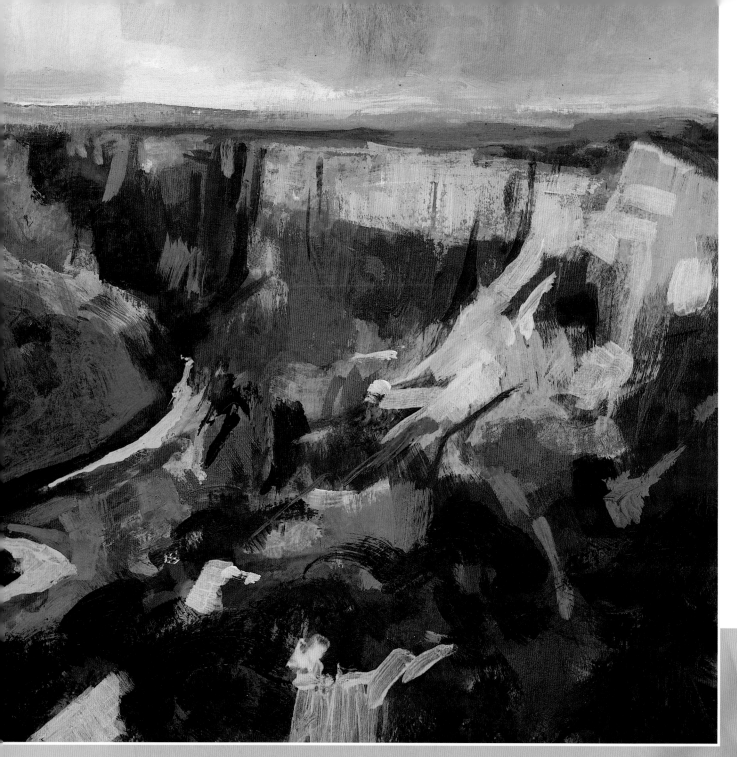

# Dragged texture

The Grand Canyon, wow! Where do you even start? Well, for me, I wanted to show the colours of this magnificent canyon, so I chose to paint using rich reds, pinks and ochres. These are tempered by the blues, both mid tone (bottom right) and powder blue (bottom left). The river also gives us the scale. Highlights are added towards the end of the painting process using dry, dragged flat brushstrokes.

### Grand Canyon #2

*The colours used here are exaggerated a little to really let the canyon sing. Contesting colours and tones are allowed to mix freely. You will, however, notice very similar vigorous brushwork between this and the paintings opposite and in Canyon, overleaf.*

# Dry brush texture

Dry brush techniques are really useful for creating implied texture and interest. The technique works in a similar way to scumbling (see page 65).

Use a brush, sponge or rag to pick up a little paint, undiluted and opaque, straight from the tube. Wipe away the excess on a spare rag, then drag the loaded brush, sponge or rag across the painting surface. This creates the 'dry brush' effects shown here. Note how the underlying orange glows through the paler yellow painted over with the dry brush technique.

### Grand Canyon #1

*This painting uses opaque dry brush techniques to paint the 'negative' shapes around the foreground shadow areas. Slightly wetter paint was used to describe the striations in the rocky canyon sides themselves, with dark glazes acting as shadows and cream highlights creating modelling on the rocks. The paint has also been applied with the impasto technique in the near foreground (see bottom right) to help create a sense of space and recession.*

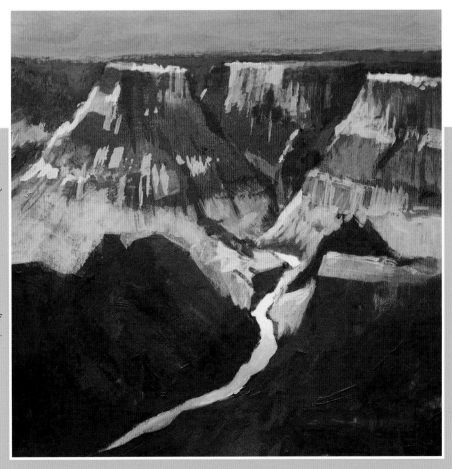

# Canyon

## 'Can you see 'em yet, Butch?'

In this case, the red sand from the canyon floor helped to lend the warmth and texture that I felt on my visit. The dark olive of the trees and pale blues in the sky accentuate the oranges and yellows in the canyon landscape.

For me, if I can recapture the sounds and smells of a location as well as the sights, I'm a happy boy. When I look at this painting I can once again hear the diamondback rattlesnake that I narrowly missed stamping on as I jumped off a canyon rock – I shudder just a little at the memory of scurrying one way as the poor snake headed the other...

**The finished painting**

## Stage 1:
## Capturing the scene

Sometimes a location just screams out to be captured in as many ways as possible, and the Palo Duro Canyon in Texas was just such a location. An absolute assault on the senses, the canyon was screaming out to be explored, sketched and painted. But for me that wasn't enough. The sand was amazingly orange, beautifully textured to the touch and just made for mixing with my acrylic paints to create instant, authentic texture.

The sounds and feel of the desert were incredible – cicadas, lizards, snakes, a slight breeze through the scrub, a whistle of wind wrapping itself around the boulders... I recorded the sounds and made a few scribbled words that described the colour and life of the area to help me remember the atmosphere back in the studio.

## What you need

60 x 60cm (23½ x 23½in) square of mountboard

Brushes: size 2 round, size 12 flat

Paints: brilliant blue, cadmium yellow, cadmium red, burnt sienna, phthalo green, titanium white, Winsor violet

Sponge
Scrap card
Painting knife
Heavy texture gel
Sand or local soil
Pencil, eraser and ruler

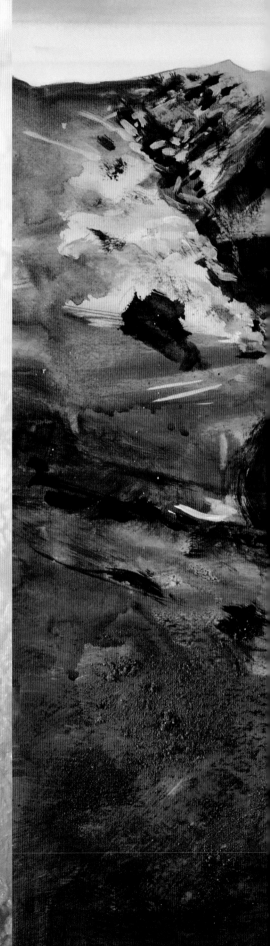

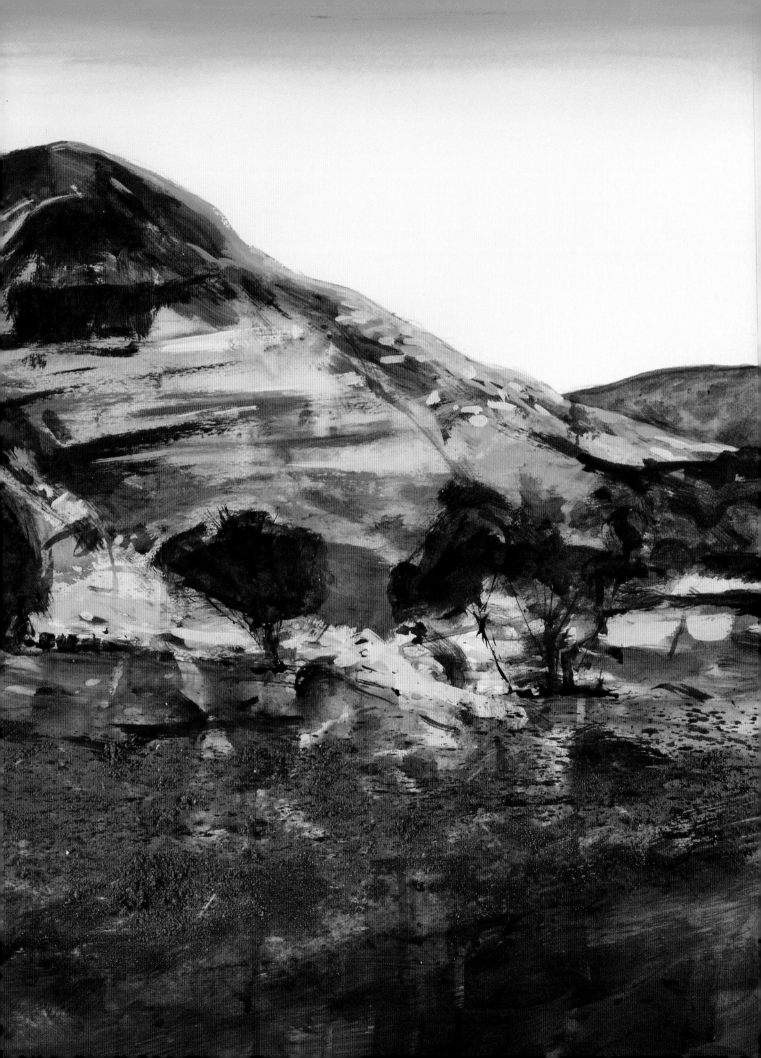

## Stage 2:
# Laying out the colours

Draw out a grid on the paper and the basic shapes using the pencil, then erase the grid lines in the sky.

Wet a household sponge, squeeze out the excess water and wet the sky area. Dip the damp sponge in brilliant blue and draw a strong horizontal stroke across the sky. Squeeze out the sponge, rinse it and draw it across the wet colour to lift out a little paint and blend away the sky towards the ground.

Use a clean piece of sponge to colour the midground with dilute cadmium yellow. Add touches of dilute cadmium red wet-into-wet. Vary the way you apply the paint by using a variety of short and long strokes, along with dabbing and tapping movements.

Use the same colours paints, but less dilute this time, to colour the foreground with horizontal strokes. Follow the contours of the ground and vary the way you apply the paint with the sponge. Use larger movements in the foreground.

Load the sponge with dilute paint. Squeeze it while flicking your wrist to scatter colour droplets over the foreground and midground.

Add burnt sienna in the midground to add a few structural darker midtones.

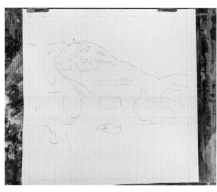

*The focus is on the ground, so the sky is restricted to the upper third of the painting area.*

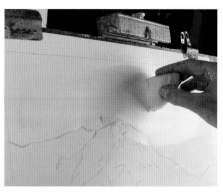

*The sheen of wet paper lets you know where you have applied the sponge.*

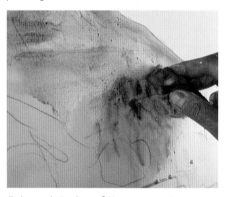

*Dabs and strokes of the sponge give different effects – experiment!*

*Squeezing the sponge while flicking your wrist works a little like spattering.*

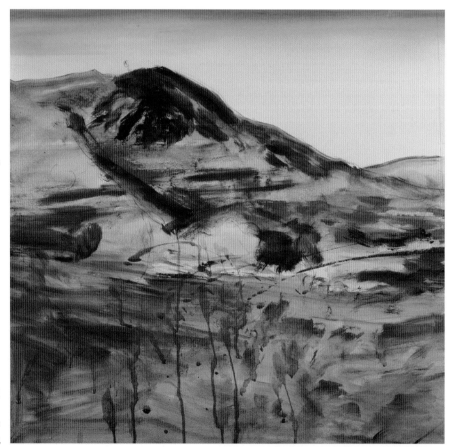

**The painting at the end of stage 2**
*The basic shapes are blocked in, and the whole paper is covered. Note the slightly lighter central section.*

# What else could you do?

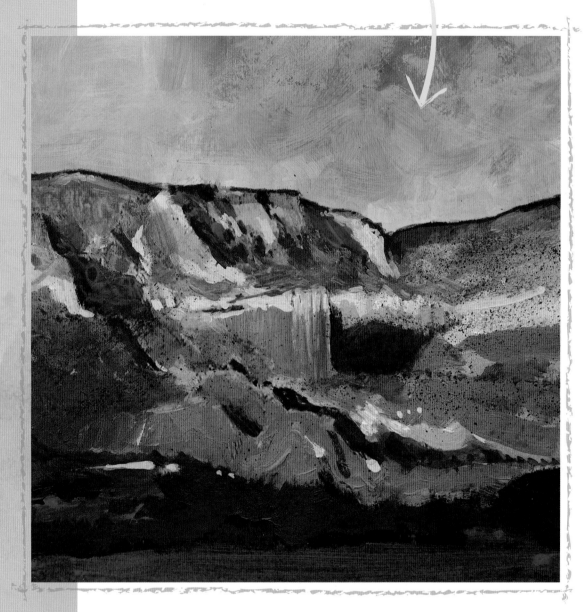

The Colours of Santa Fe

## Local materials

I regularly use material from wherever I happen to be working — Texan canyon sand for the demonstration painting on these pages.

Litter from the streets of Paris, shells from my local beach, earth from the mountain top and fallen leaves in New England... It's all valid, so look around you, and see what you can find to jump start your work.

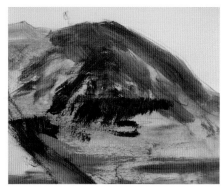

*Brush downwards to create texture.*

*Lifting away the mask reveals clean lines.*

# Stage 3:
# **Texture and trees**

Still using the sponge, mix burnt sienna and Winsor violet for a dark colour. Hold up some scrap card and brush down across the straight edge to create harder textural darks.

Use small touches and strokes to build up the texture in the background, then build up the foreground with larger marks using more dilute paint.

Without rinsing the sponge, pick up phthalo green. This is a blue-green which is a complementary colour to the red-orange used so far. Use scrubby, rounded strokes of this paint to suggest midground foliage. Again, use the card to create hard edges, this time at the bottom of the tree areas so that they appear grounded.

*A sponge can be used as a brush by dragging it.*

*Fill the sponge with dilute paint, then squeeze it to release the liquid and add new textures.*

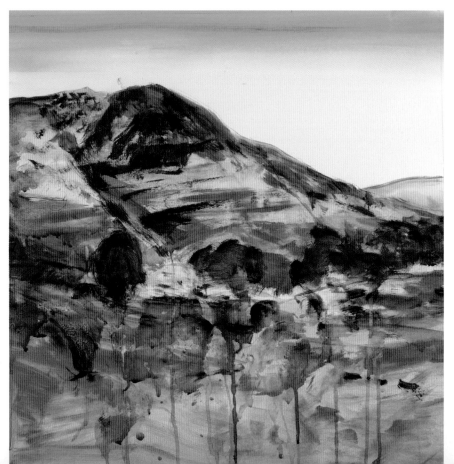
*Hold the card underneath the area you are sponging to make trees.*

### The painting at the end of stage 3
*Detail added in the midground and background areas begins to give the landscape shape.*

# what else could you do?

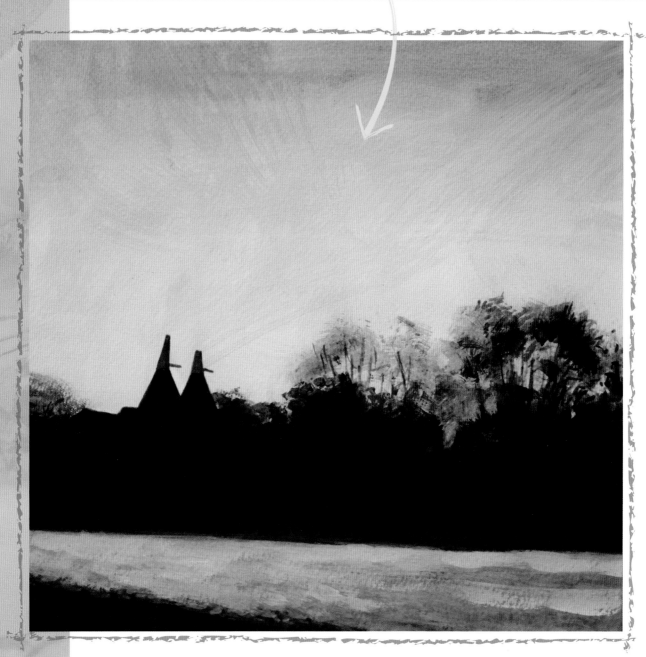

**Summer Light – The Garden of England**

## silhouetting

An alternative way to create the focus on your subject is to use a silhouette.
A simple and dramatic composition can be made by using little if any detail
and an intense, deep, rich shadow on your subject can increase mystery and
intrigue. It helps if your silhouette has a recognisable outline such as the
Kentish oasthouses in this painting, but trees, city skylines and figures all
work well as silhouettes.

## Stage 4:
# Tonal contrast

Use the corner of the sponge with less dilute phthalo green to reinforce the centres of the trees and to add small bushes. Dilute the mix and flick the colour across the background horizontally. This suggests grassy textures. Mix titanium white, cadmium yellow and cadmium red, then use a size 2 round brush to apply the mix to add details and highlights in across the midground. Vary the proportions of the paint colours for natural variety.

These tiny touches should be used to break up large blank areas, adding interest and suggesting the stratified nature of the rock with horizontal strokes. You can also develop the large marks made earlier, to refine them a little. With these complete, add a hint of brilliant blue to the phthalo green and glaze the background hill.

Using the light marks you added earlier to guide you, use a dilute mix of phthalo green to add small dark marks, painting in and around the light marks to create tonal contrast and interest.

Continue to work by building up the dark and light textural marks with the colours and techniques used earlier. Work intuitively, and stop when you have to start thinking about what to do next.

*Protect the sky with a card mask when flicking.*

*Light tones are used for highlights.*

*Glazing the background hill.*

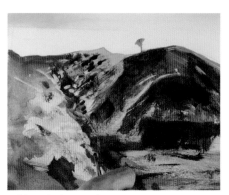
*Adding darker marks creates contrast.*

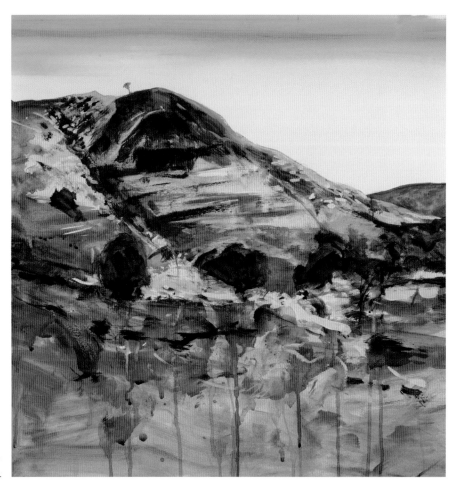

**The painting at the end of stage 4**
*The basic painting is now ready for textural additions.*

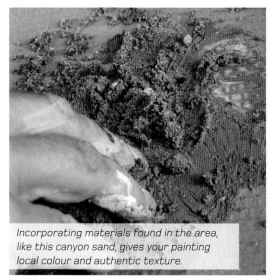

*Incorporating materials found in the area, like this canyon sand, gives your painting local colour and authentic texture.*

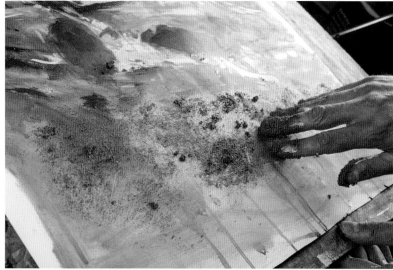

*Smear the sand and paint mix over the foreground only.*

## Stage 5:
# Texture and finishing

Use a painting knife to mix cadmium yellow and cadmium red into heavy texture gel, then mix in some sand or similar soil from the area you are painting. Lay your painting flat and use your fingers to apply the mix around the central foreground, leaving the edges clean.

Using the size 12 flat brush, apply a mix of Winsor violet and burnt sienna around the edges of the foreground.

Spatter the same mix across the sand area, then use the edge of a painting knife to apply a dark mix (burnt sienna and Winsor violet) across the border between the foreground and midground, where the trees sit. Use the edge of the knife to create the impression of branches and trunks in the trees.

This completes the painting – though feel free to make any further adjustments or personal additions you like. My finished version is shown on pages 110–111.

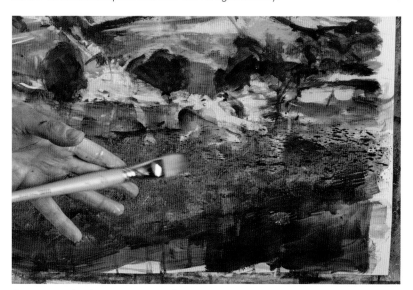

*Spattering develops the texture further.*

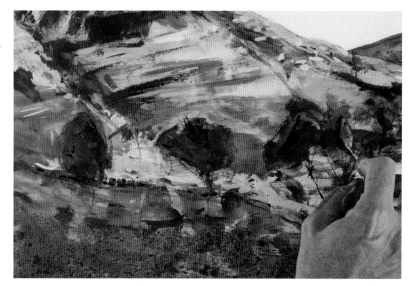

*Shaping lines and hard edges in the trees with a painting knife is simple and fun.*

# What next?

I like to give myself some parameters when working on landscapes. Firstly I ask myself if the landscape is the main subject or a supporting role? When that's decided I then begin to look at variables in the landscape such as the atmosphere and feel of the location. Is there a poetic majesty in a Canadian mountain view or a sense of liberation? What about a rugged Yorkshire stone wall? A feel of ancient sturdiness or a sense of mystery?

Summer fields ablaze with meadow flowers will require a different treatment from the same field full of wheat, ready for harvest. The fragrance from the flower field may be perfumed, sweet, gentle; while the field of wheat will have an earthy scent, one of wholesome, honest labour... and how do the fields sound? The flower field is full of buzzing insects and popping seed heads, while the wheat field captures the rhythmic sound of the swaying breeze.

How does your local landscape change throughout the seasons? What differences appear in its colours, sounds, atmosphere and essence?

The more we can adapt our work to better reflect these natural changes, the more successful, interesting and enjoyable our creative endeavours become.

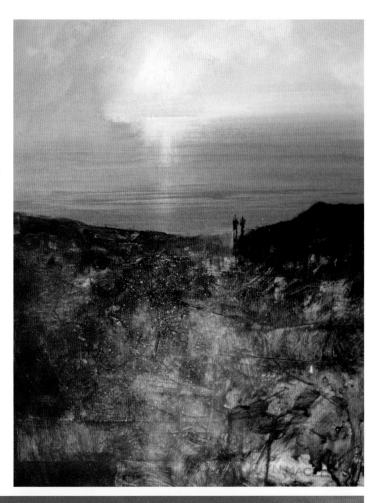

*Top:*

## Beachcombers

*Layers of paint were applied with an old rag to create the texture and interest in this landscape. The randomness of the foreground area is accentuated by the calm, smooth sea while the figures draw the eye to the edge.*

*Right:*

## A New Day

*A man-made landscape, so ancient that it appears to have grown from the very earth itself, comes to life with the gentle touch of the sun. Sometimes the focus of a painting can be left to the interpretation of the viewer. In this case, is the focus the majestic stones of Stonehenge itself or the even more majestic rising sun?*

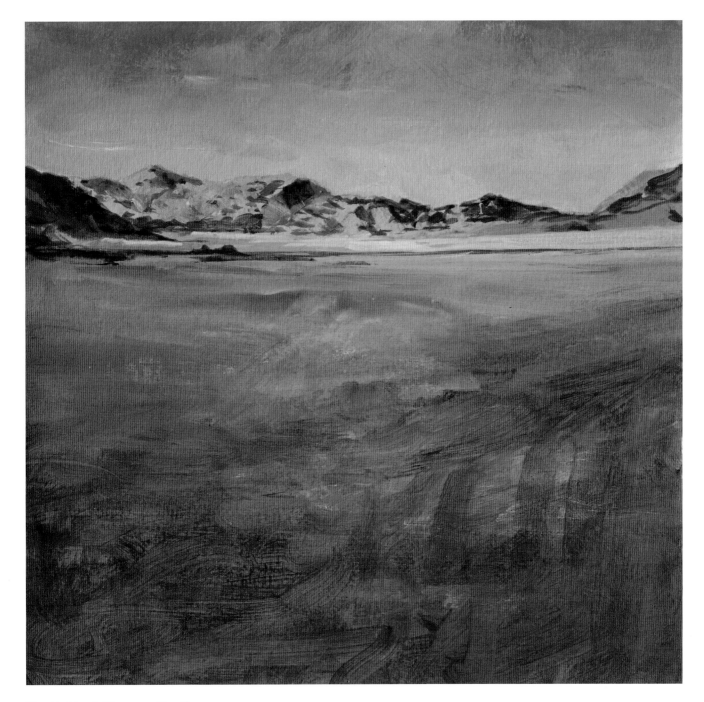

## The Hottest Place on Earth

*Escaping the tourists' camera clicks to the silence of the desert, this study of Death Valley in the USA makes use of cool blues to help accentuate the rich orange and red and suggest the 56ºC (130ºF) heat. The Mars-like red of the Death Valley floor is emphasised by the use of cool blues in the distant shadows and unrelenting clear blue sky. There was no time for collaged sand with this one, due to the extraordinary heat which was drying my paint as I squeezed it into my palette. Sometimes speed is of the essence; Mother Nature in all of her variable forms makes sure of that.*

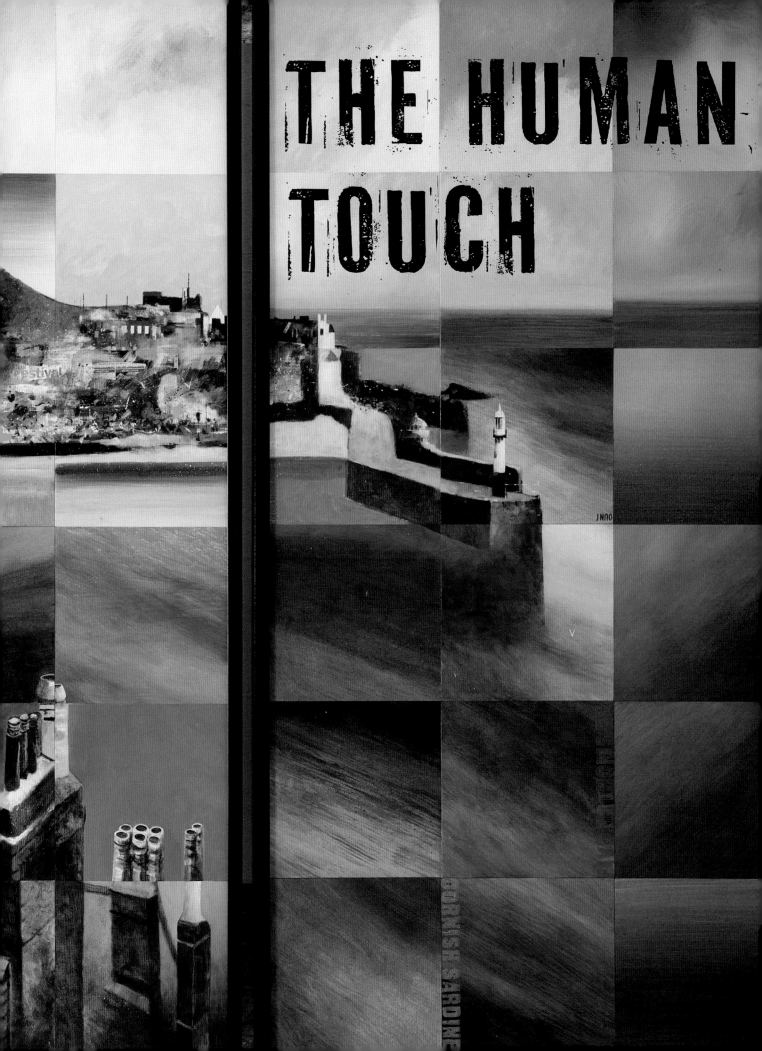

# THE HUMAN
# TOUCH

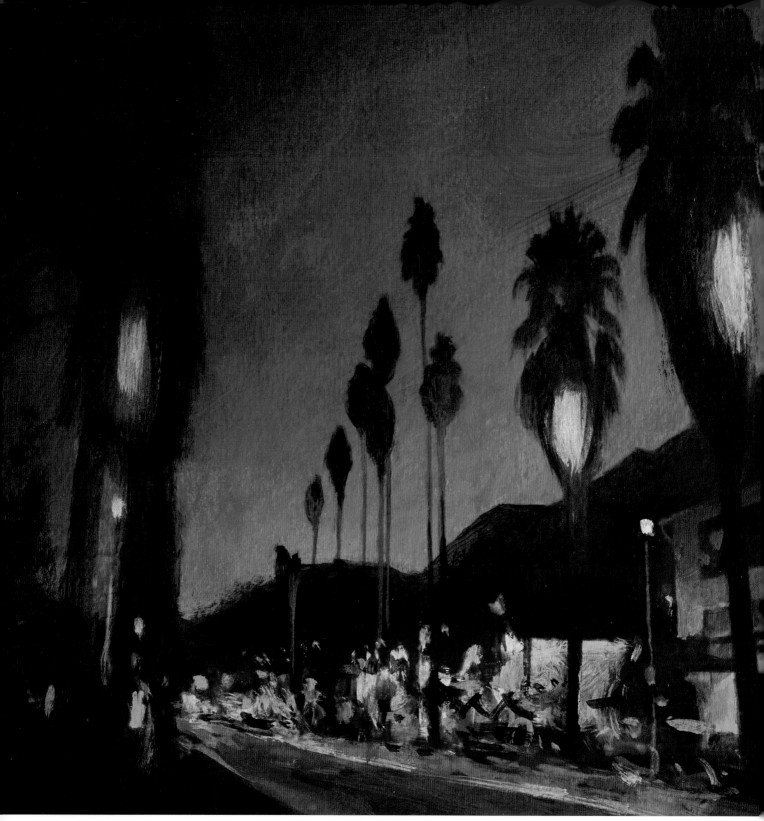

## Palm Springs

*My focus in this study was to create the impression of 'buzz' on a hot, relaxed evening.*
*Simple dots and dashes imply people, buildings and signs. These 'busy' marks provide a foil*
*to the otherwise flat and calm areas of sky, palm trees and distant silhouettes.*

# Life

So, we have painted the sea, we have sponged the sky, and we have scumbled our way through woodlands and wilderness. What else is there?

This is the chapter that brings everything together. This chapter is all about life, human activity, movement, excitement and atmosphere; and this is where a lot of the interest in creative artwork resides. Movement, activity, noise, calm, quiet, joy. These moods and emotions are key.

Above all else, I love to paint 'life'. Using figures, advertising signs, lights and all the myriad pictorial elements associated with an urban landscape, we can add real character and real atmosphere to our work.

Of course, painting people, street architecture, vehicles and signage can be and would be difficult and time-consuming if we focused on the precise detail. But if handled with a more abstracted approach where we 'imply' detail, suddenly the painting process becomes a whole lot easier, more enjoyable, fun and satisfying. What is more, these techniques and approaches work in pretty much any situation and for pretty much any subject matter, from harbour sides to backstreets, from farmyards to cities.

The following pages focus on adding these essential compositional elements, and with a flick of your wrist, a cut-out shape, a glue stick and a toothbrush, you will soon be adding essential 'life' to your paintings.

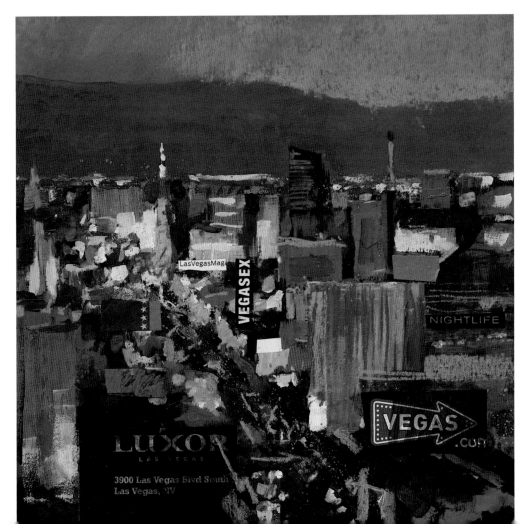

Las Vegas, USA

# Opportunities and challenges

For me, to incorporate human interaction into a painting allows me to capture and sum up the essence of a location. The buzz of New York, the quiet calm of a Venetian backwater, the fresh air and noisy bustle of my local quayside or a languid, summer day down on the farm. Let's not forget the animal and bird life – birds singing, bees humming – which can transform a painting, both in a compositional sense and in atmosphere.

As I write these words, I am painting an early morning dog walker down on my local beach. I ask myself, "Is it possible to capture the dog's bark as it chases the oystercatchers, in just a few strokes?" Similarly, when I was last in London, working deep down in the King's Cross St Pancras Undergound station, I took in the atmosphere: full of little chatter as sardine commuters read their daily newspapers and smart phones, and a regular, heavy rumble as rolling stock draws near – before the whoosh of warm, dank air as the wheels squeal into the station. Can I capture that claustrophobic atmosphere using colour? These are the kind of questions that I ask myself before every painting session; in fact, these are questions that I ask myself before every brush stroke...

# Useful equipment

Sea, sky, land... whatever the subject, life can be brought into any painting; and for this reason, you can use any or all of the tools and materials we have used so far in the book for these paintings.

This part of the book is the culmination of all you've learned, so have at it with any paints, tools, materials and techniques you like! Flick back through the book if you need a little a reminder or some inspiration – I hope my paintings give you some fresh ideas of your own to bring life to your artwork.

### Halloween

*The large dark areas of Halloween are painted using a sponge dipped in ink-black paint. The sponge was allowed to drip and splash to create knocked back texture and intrigue. The same paint was drawn up to form the window and door frames using a found stick. Once it was dry, I used negative painting to create the figures and window panes by adding pale lemon-whites around them.*

## St Paul's Sunrise

*This uses a central composition, keeping the main focus in the centre of the painting. A central composition often creates a calm feel. Added to this I chose to use a very limited palette of warm colours for the same reason. The calm of the warm sunrise just as the city begins to wake up was the inspiration for this painting. Gentle brushstrokes relax the eye and the sinuous river guides the eye from bottom left curving through the right side to arrive at the sunrise and the dome of St Paul's Cathedral itself.*

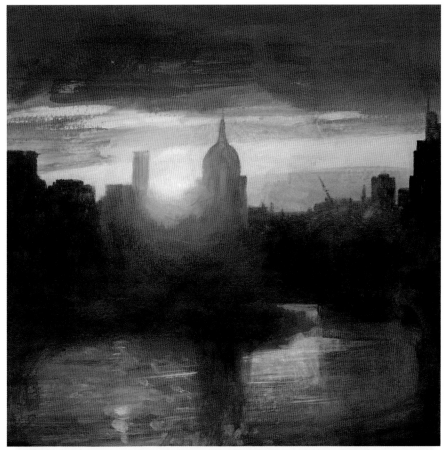

## London at Night

*The same subject takes on a whole different look and feel with crisp lines and a dramatic colour palette. I tried to capture the exuberance of the city night by using the deep inky blues and crisp silvery whites. Sharp lines, both horizontal and vertical, add a certain confusion to the composition as does the flickety-flicked river surface. The bright red and gold touches draw the eye in and bounce the gaze across the picture plane.*

# Composition

Composition is a complex subject, and one that really needs a book of its own to explain fully. Built-up areas, the insides of buildings or manmade objects like boats and vehicles can be particularly complex, so it makes sense to look at composition in more depth here in the section on life.

A neat method that I use to arrange compositions is to cut basic block shapes out of paper or thin card. Each block represents an element in my 'imagined' image. It is then simply a case of moving these paper elements around until a satisfying composition is found.

This technique is particularly useful when used with more abstracted work – it is also a great way to get started if you are nervous; it's just moving paper around until the shapes look right to you. Once the composition is arrived at, we can then fill in the blocked areas with the painting subjects themselves.

The paintings on the following pages demonstrate some compositional tools and ideas to help you produce paintings that will catch the eye.

### Cromer

*This painting uses the rule of thirds (see pages 128–129) to place the main area of interest in the top right-hand corner. I have also used the pier railings and boardwalk to draw the viewer's eye to the same area. Combined with a mishmash of brightly coloured buildings made from collage materials, the attention is then held on the town itself.*

## Westminster Reflection

*The rule of thirds once again comes into play in this painting, combined with a composition based on an offset triangle. The eye is drawn across the picture plane from left to right before following the tower of Big Ben to the clock face.*

## The Station

*Converging perspective lines take the eye through the claustrophobic, bustling station out into the daylight. At the same time horizontal and vertical lines help to confuse the eye, adding to the noisy atmosphere.*

# The rule of thirds

There are many ways to create a good composition, and some work better for certain subjects more than others, but there is one compositional device that works right across the board, and that is the 'rule of thirds'.

The rule of thirds states that if we divide our painting surface into three horizontal sections and three vertical sections – almost like a noughts and crosses or Tic-Tac-Toe board – and follow this by placing the main point of interest in either the top left, top right, bottom left or bottom right of the picture plane, we will automatically create a pleasing composition. It works – every time!

If you have ever used a digital camera, you will probably have noticed the compositional lines on the viewfinder. These viewfinder lines are the rule of thirds in action.

# The grid

This detail shows the painting with an overlaid grid of lines to demonstrate how the rule of thirds was used in this painting. Note how the top of the boat runs along the line between the top and middle third of the painting, and the boat stretches from the left-hand side to two-thirds of the way along.

The places where the lines cross over are good places for the focal point. Here, the prow of the boat sits on one of these intersections (marked A on the picture).

The sky occupies the top third of the painting, and the ground beneath the remaining two-thirds. Having the horizon line offset like this is a good way to create an interesting picture.

## Cromer

*Although these paintings are quite different in content, the underlying composition is similar – the sky occupies the top third, the bottom two-thirds are relatively open and clear, and the majority of the detail runs along the line between the top third and the rest of the painting.*

*As a general rule, avoid having the horizon halfway up your paintings – though this is far from a hard and fast rule. A painting divided into two main parts can work really well. Here, although the horizon line runs along the top third, the eye-catchingly bright beach and dark town split the painting almost exactly in half.*

*Note also the railings that lead from the bottom of the painting on the left up to the centre line on the right-hand side. This has the effect of leading the eye into the painting.*

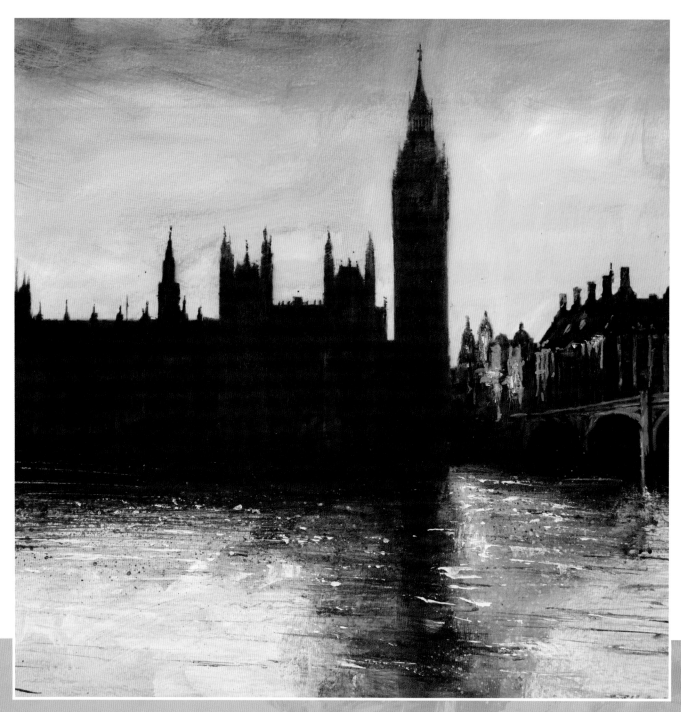

## Balanced composition

Glazing techniques combined with opaque highlights are used to capture the soft magical London light in this atmospheric painting, and the composition is key in creating a correspondingly calm feel. To achieve this, the painting is balanced with the sky and water framing the skyline.

The sky and water are similarly light in tone, with the buildings providing a strong, anchoring dark contrast. Most of the detail is restricted to the central part of the painting – try using the rule of thirds grid (see pages 128–129) to check!

### Thames Light

*The colours of London. A sparkling city, twenty-four hours a day, seven days a week...*

# Glazing

Glazing is a technique that will be familiar to watercolourists or oil painters. It involves using very diluted paint to paint over underlaying layers. Because the paint is so watery, you can see some of the underlying colour showing through.

This can be used to add vibrancy and beautiful atmospheric effects to your paintings, as in the example on the opposite page. Here, glazes have been used over a bright underlayer of primary colours, transforming a simple composition into a finished painting full of light and atmosphere.

**1** Allow the area you want to glaze to dry completely. Dilute the colour you want to use down to a very watery consistency.

**2** Load the brush with the diluted paint and work over the top of the area. Note how the underlying colour shows through.

**3** Different colours will affect the underlying colours differently. Allow each to dry thoroughly before continuing.

**4** Further colours can be glazed over the top of previous layers. Use a glaze of white to 'knock back' the colours beneath. This is useful for creating a sense of distance in the background of paintings.

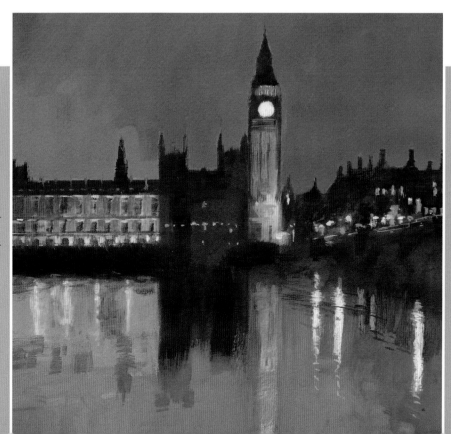

## Westminster Reflection

*This painting shows the same scene as in* Thames Light *(opposite), painted after sundown. Here, the reflections are even more obvious and become a more important part of the composition. For this reason, more space has been left for them, resulting in the horizon line sitting at the exact halfway point of the painting. This mirror effect creates a striking but peaceful scene.*

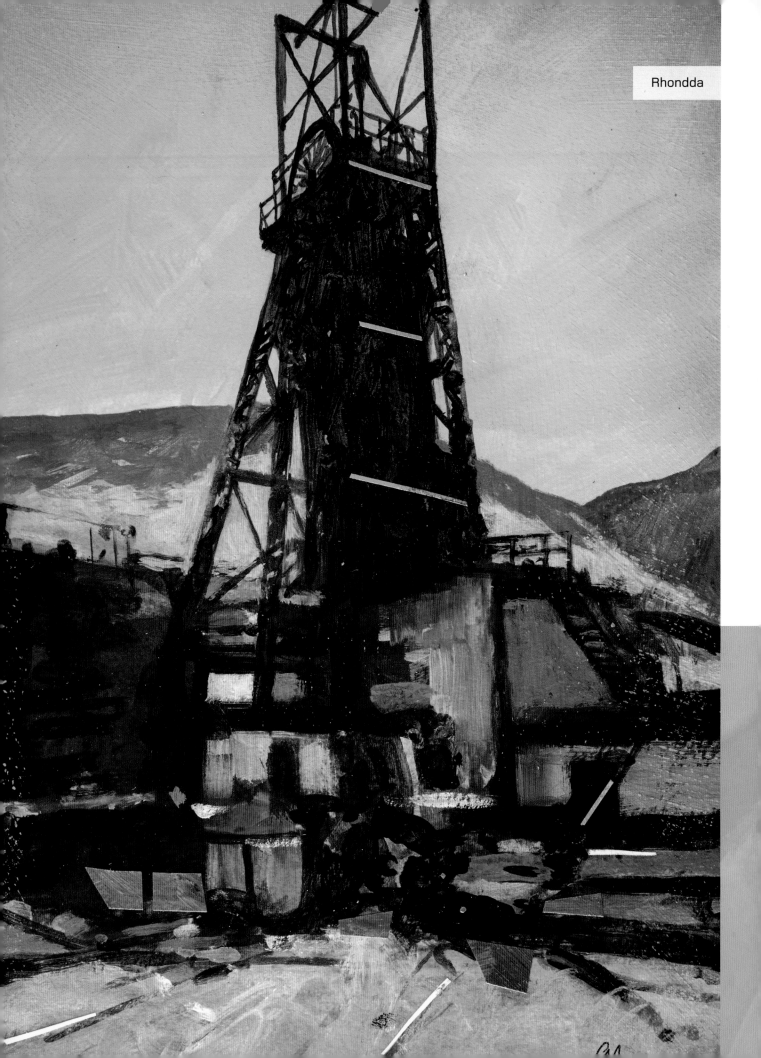

# Experimenting with collage

Buildings like this pithead in the Rhondda Valley in Wales can make for exciting, dramatic pictures, but there's no need to panic about their complexity. Collaged elements can be used to create crisp lines and shapes. They will create contrast against the softer brushwork; and you can move them about before you stick them on (using a glue stick). This allows you to experiment with placement before you fix them in the final position.

## Giving your paintings personality

While using collage parts, why not alter the angles on your image? Does a change of angle increase the atmosphere in your painting? Does a change of angle make your painting more dynamic?

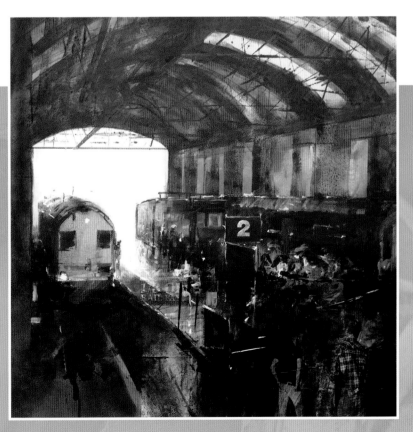

### The Station

*There are numerous ways to paint straight lines, from using small brushes and a steady hand to masking with tape. But my personal favourite is to stamp lines onto the painting surface, as in the station roof of this example.*

*I like to use the edge of a piece of stiff card as my 'stamper'. To stamp lines onto your work, simply paint the edge of your card with acrylic paint then place the painted edge firmly on your surface. The resulting line will often appear imperfect, which in my mind is a good thing, as imperfect lines have character and life. If your line does not quite work for any reason, simply wipe it away with a damp sponge while the paint is still wet and try again.*

# City of Life

For me, the key to painting pieces full of life and interest is to combine a variety of techniques. In this instance a combination of brush work, both large and small, with a touch of conté work and collage, helps to bring to life the bustle of the evening city. Working in this way allows accidents to occur. Juxtapositions happen of their own accord and the resulting image hopefully sparks interest. Throw away that book of rules and instead open up your bag of tricks.

**The finished painting**

## Stage 1:
## Capturing the scene

On location, a quick photograph and a few sketch pad compositions will give you a basic set-up for this painting. However, in this instance the tactic that captured the real essence for me was a simple sound recording made on my phone. The wind whistling through the bridge structure, the distant sirens, yellow cab beeps and – as if to say "don't forget us!" – the excited quack from a family of Hudson riverside ducks.

   Listening back to these recordings, I am there once more. The atmosphere comes flooding back: the colours, shapes, light and shade. The frenzy, the excited bustle and the 24/7 life of this most vibrant of cities. I know that this painting needs rich colour, sharp-edged collage and soft blurred brushwork to capture some of that energy... It's time to begin.

## What you need

60 x 60cm (23½ x 23½in) square of mountboard
Brushes: 5cm (2in) household brush, size 12 flat, size 4 flat
Paints: phthalo blue, titanium white, burnt sienna, cadmium yellow and cadmium red

Scrap card and paper
Scissors and glue stick
Old magazines or coloured paper
Pencil, eraser and ruler

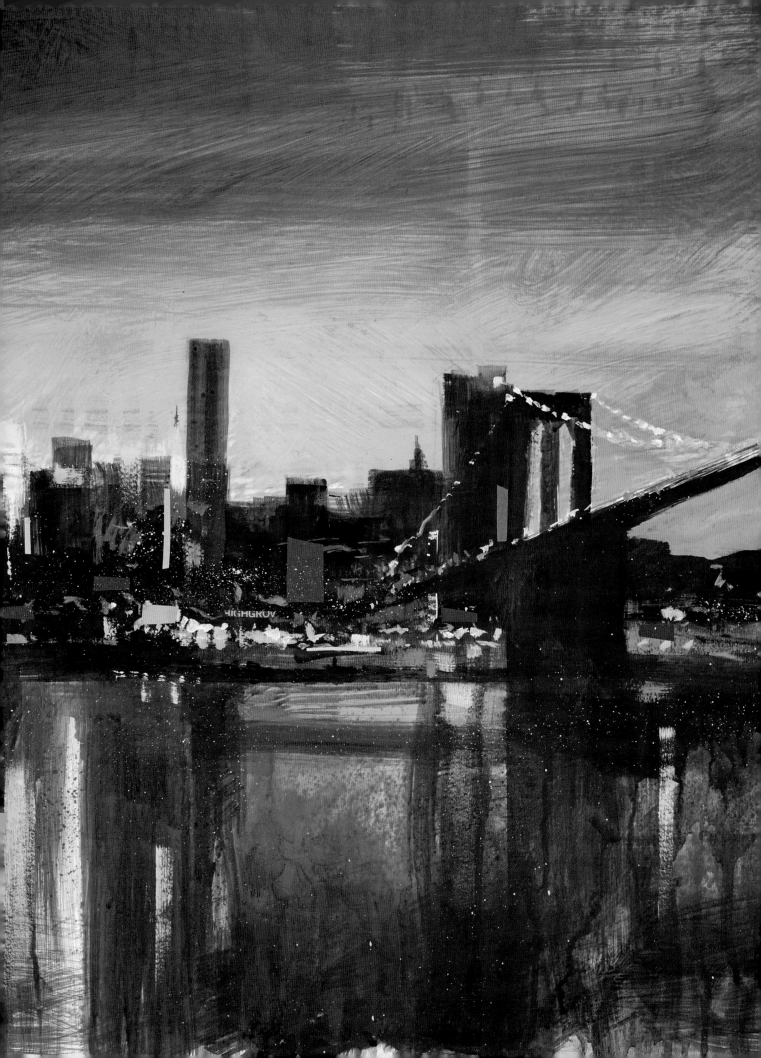

# Stage 2:
# Underpainting

Draw out a grid on the paper and sketch out your basic shapes using the pencil. Use a 5cm (2in) household brush to lay in horizontal strokes of phthalo blue across the sky, working down from the top. As you work down, pick up water without rinsing the brush, so that you get a faded effect. Pick up a little titanium white and blend it in wet-into-wet above the building, and gently brush the colour over the whole sky to break up obvious brushmarks.

Next, load the brush with more dilute phthalo blue and paint in the reflections of the sky in the water, leaving gaps for the buildings and allowing the paint to drip down the surface. Still using the dilute blue, tap the brush sharply on your hand to spatter the water area.

Block in the skyline buildings using the size 12 flat and a dark mix of burnt sienna and phthalo blue. Dilute the mix with water for variety and reflections. Rinse the brush and pick up burnt sienna. Use this to warm up the foreground area while bringing out the main buildings, working over the blue and dark areas. Add more simple detail with square brushstrokes – i.e. clean horizontal and vertical strokes.

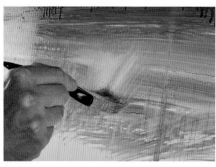

*Blending white into the sky breaks up any texture or brushmarks.*

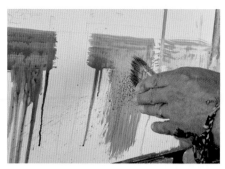

*Spatter over the whole river, even the areas left clean for the buildings.*

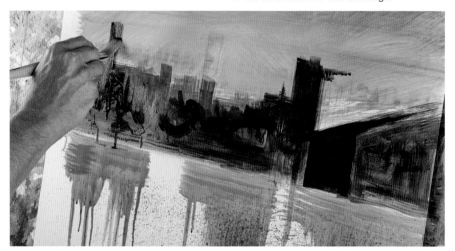

*Block the buildings in cleanly but quickly – don't get bogged down in detail.*

*The blade of the brush can make fine lines quickly.*

## The painting at the end of stage 2
*Allow the underpainting to dry completely before continuing.*

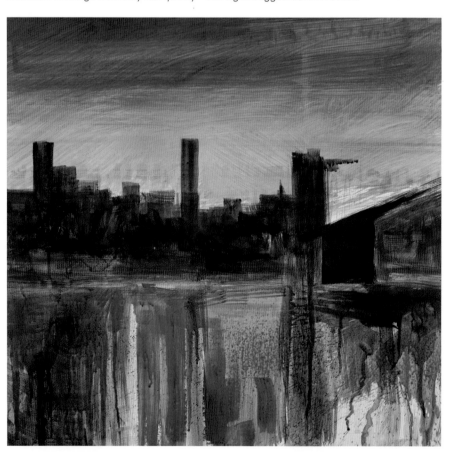

# What else could you do?

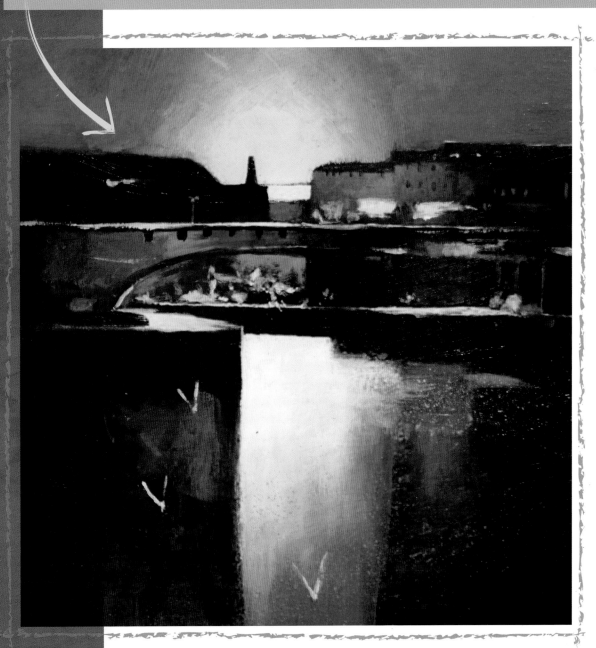

## Contrasting detail

Not all settlements have lots of artificial lights, but there are other ways of adding small points of contrast and interest.

In this example, which uses a similar palette to *City of Life*, the detail on the bridge is made with regular darker marks. To make these sing out of the bridge itself, the tones used on the underlayer are light – it is the contrast that is important.

Note also the seagulls in the foreground, added using quick strokes of a fine brush to make small 'v' shapes. Of course, you could just as easily use a twig or piece of found material to add these details and achieve the same interesting broken lines.

### Bristol

*The gulls used in this painting help to draw the viewer's eye from the foreground through the modern bridge to Brunel's suspension bridge in the distance.*

*Stronger darks add impact.*

*A card mask will help with straight lines.*

## Stage 3:
# Structures

This stage requires a little more control, so adjust your grip accordingly. Almost everything here can be painted with the size 12 flat, though you can change to a size 4 flat for more control if you wish. Continue to develop the city by building up the dark areas with the dark mix (burnt sienna and phthalo blue). Use the colour slightly diluted so the underlying colour shows through, but not so thin that it drips.

For the hard edges of buildings and the bridge support, use a mask of scrap card – hold it up and draw your brush down. Lift it away to reveal the hard edge. With the city complete, build up the reflections with dilute versions of the same mix. Add less detail so that the focus remains on the city itself.

Add a row of cadmium yellow lights with the corner of the size 4 flat.

*Keep the lights on the same plane – these are car headlights, so they need to be in a row.*

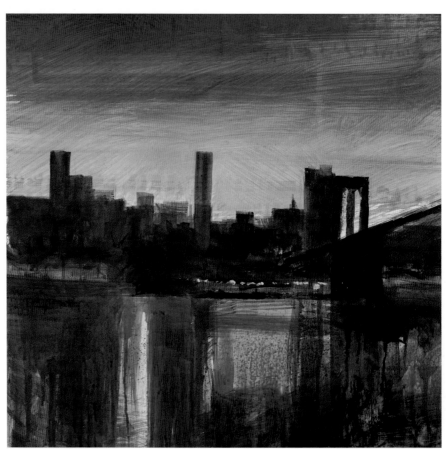

**The painting at the end of stage 3**
*Even a small amount of detail starts to make sense of the basic shapes.*

# What else could you do?

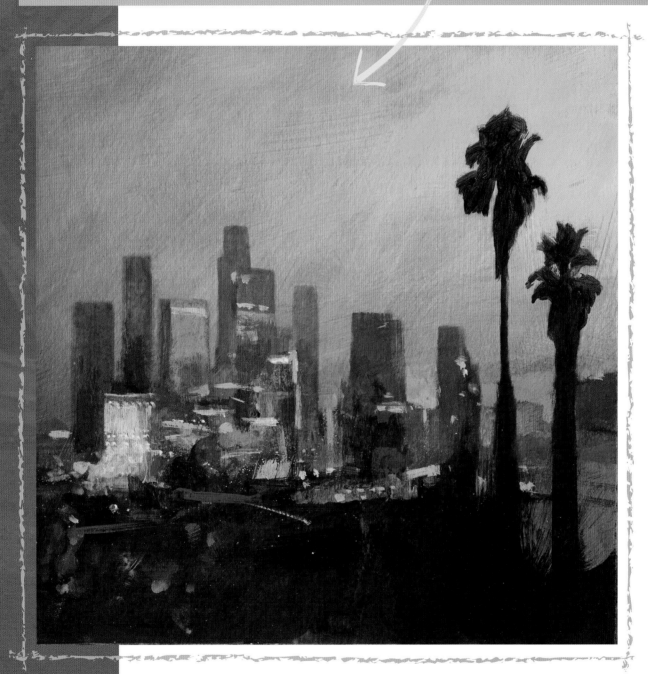

## Fine paintwork

Collage details create hard lines, which is fantastic for suggesting the structures of buildings in the foreground, particularly for cooler coastal scenes like the city in the main project. However, for buildings hidden slightly in mist, fog, or in the haze of a hotter climate, brushwork details help to soften your marks and can suggest distance, as in the background buildings of the example above.

### Los Angeles

*Combining warm colours in the sky with cool blue buildings creates strong, punchy contrasts. This helps to describe the heat of a Southern Californian evening.*

## Stage 4:
# Lights and fine marks

Hold a sheet of card up in line with the lights, then use the corner of the size 4 flat brush to add an orange mix of cadmium yellow and cadmium red across the sea line. Make these marks less distinct than the yellow lights by holding the brush lightly on the ferrule so the bristles can move freely.

Continue to build up these lights across the painting, keeping them restricted to the line of the city street, not up into the buildings. Add white to the mix for variety and use this lighter mix for the bridge lights. For reflections, apply the same colours but with short vertical strokes and less pressure.

Introduce phthalo blue and burnt sienna and add more marks with small, light touches.

*Keep the lights near the horizon line and the bridge.*

*The fine lights on the bridge are an important compositional feature.*

*Blue and orange marks build up the impression of vibrancy and life.*

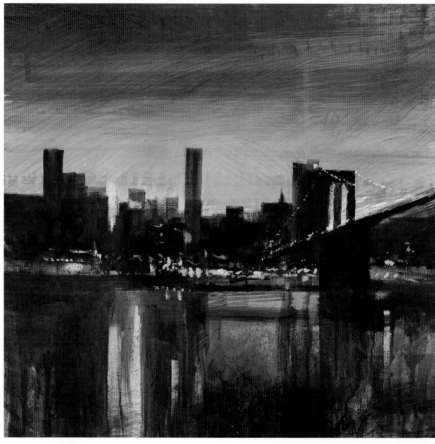

**The painting at the end of stage 4**

*The city now begins to look inhabited.*

*Small collage pieces in strong shapes and colours (see above) bring crispness and interest when added to the city.*

## Stage 5:
# Finishing

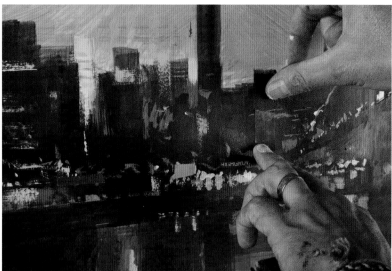

Use scissors to cut out some small, bold-coloured rectangles from magazines. Find mainly reds, oranges and yellows, but include some deeper colours that match the blues and browns of the city shadows.

Use a glue stick to attach most of the red, yellow and orange pieces along the street level. This creates really crisp, eye-catching details that reinforce the focal point, and suggest the signage and hustle and bustle of city life.

Dot the deeper colours around the city, concentrating them near the focal point – you can always peel them off or cover them later, so relax and enjoy experimentation.

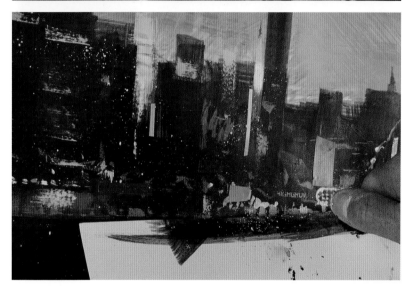

*Spattering suggests movement and lights.*

Make a milky mix of titanium white and cadmium yellow and dip an old toothbrush in the paint. Draw your thumb across the bristles to spatter the paint horizontally over the city. Use scrap paper to protect the sky when spattering near the buildings.

To finish, mix phthalo blue with titanium white to match the sky near the horizon and block in an area of blue sky beneath the bridge. This draws more attention to the bridge and throws the structure towards you. Use any paint remaining on the brush to blend the colour into the sky above the bridge.

*Blending the new blue mix into the sky.*

# What next?

Throughout this book we have worked our way through processes to capture the oceans and searched for new ways to describe the elemental sky. We have splashed the paint on our surfaces with abandon, with relish, with fun; and we have endeavoured to capture the atmosphere of life itself.

For me, writing this book has been a real journey. I have delved deep down into my way of working and my way of thinking. Painting is a process that I do naturally and one that I have never really analysed before. What I realised along the way is that the elements that work for me can work for you too. My way of observing the world and translating it into artwork is akin to a pick 'n' mix affair – a touch of this added to a little of that: recording the conversations, the birds, the waves, the traffic. Making notes of the music that inspires me on the day; or the heat of the sun and the chill of the rain. All of these sensations and notes feed back to me the atmospheric information that I crave.

Perhaps not all of my ideas will appeal, but hopefully they have helped you to gain a deeper understanding of your own work – the whys and the hows. I sincerely hope that a few of my ideas may work their way into your own creative endeavours; and if they do, I'd love to see the results!

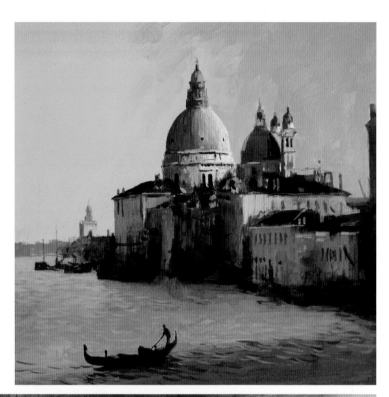

*Top:*

## Gondolier

*Life meets the sky meets the sea, and nowhere on earth do these elements come together more beautifully than in Venice.*

*Right:*

## Route 66

*Man has made his mark in the most remote of locations. Here, the inhospitable heat of the desert landscape has been infiltrated by a line of diminishing telegraph poles following the long, straight road.*

## Oxford Pink and Purple

*The vertical spires breathe life into an otherwise horizontal composition. This painting was made on location just after a summer sunrise, so is altogether calmer in feel than City of Life. I used more controlled brushwork with a subtle colour palette to try to sum up the stillness of the dawn.*

## Mississippi

*I can never resist painting the wonderful bridges of the world, and a bridge that crosses one of the world's great rivers is a must. I painted this from below and into the light to create the silhouette shapes and detailing, aiming to capture the graceful 'leap' of the structure. As with the Oxford painting above, this was painted to be calm in feel.*

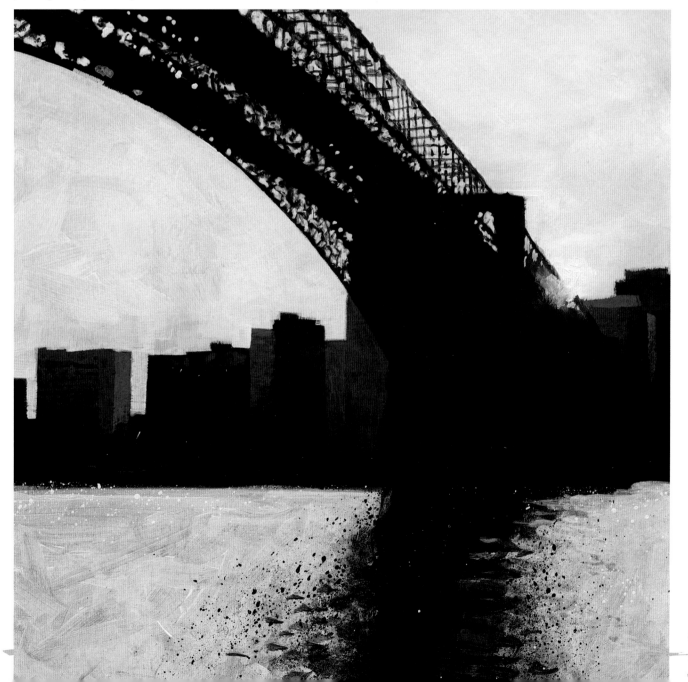

# Index